THE MANGA ARTIST'S HANDBOOK
DRAWING BASIC CHARACTERS

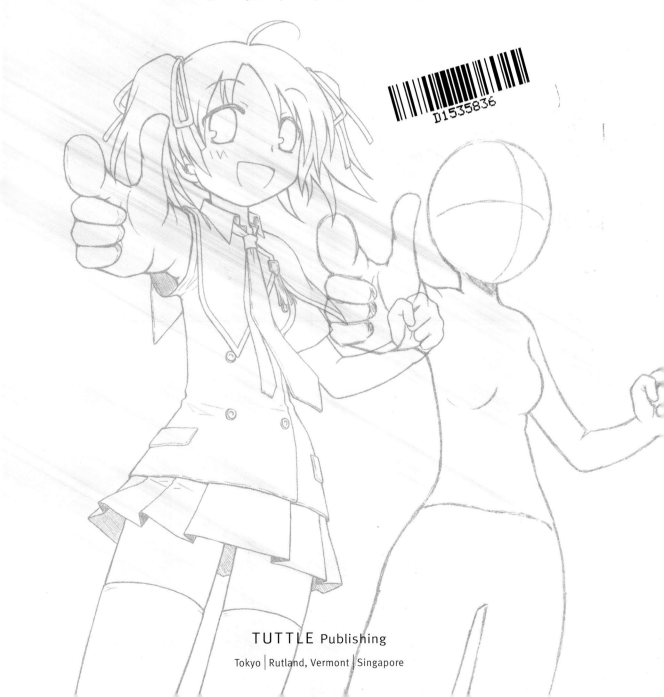

D1535836

TUTTLE Publishing

Tokyo | Rutland, Vermont | Singapore

CONTENTS

CHAPTER 1 Basic Poses

CHAPTER 2 Signature Poses

FOREWORD

HOW CAN I IMPROVE MY DRAWING SKILLS?

Manga artist hopefuls are always taught that they should practice sketching over and over in order to improve their drawing, and lots of books have already been written to help artists develop their sketching skills. But even if you've studied hard at the sketching stage, do you still get the feeling that your work somehow looks unbalanced? Maybe the head is too small, or the arms are too long, or some other body part looks strange. Why doesn't your drawing look quite right when all that sketching practice you've done should have given you an understanding of the body's form?

In this book we'll look closely at the importance of balance when sketching figures and how you can achieve it in your work. A well-balanced picture is composed of elements which are all "just right" in terms of size, position and so on. If you ask someone who is good at drawing how to draw a well-balanced picture, they will tell you it's about careful observation as well as careful drawing.

Simply understanding the form of objects via sketching doesn't mean you can draw a well-balanced picture. It is the process of observing things that are "just right" with your own eyes, and drawing them, that will gradually allow you to gain this skill. This is called "having a sense of balance."

This book gives you the chance to develop your sense of balance by providing sketching exercises for a wide range of poses whose balance is "just right." Have fun incorporating them into your own manga and see how good your pictures look. By the time you've completed all the exercises in this book you'll have a much better understanding of what "just right" is, and you'll be amazed at the difference in your work!

What is Blocking-in?

Blocking-in allows you to try out a figure's pose, the overall composition, and so on, to get the general idea of a drawing before you start.

When professional manga artists and illustrators draw their works, rather than going straight to the actual illustration, they usually first pencil in lines to block in a figure, after which they use pencil to go over these lines and form a preliminary drawing. (Following this, they go over the drawing in pen and add color.)

The marks made when blocking in are not strong and bold, but light and easy to rub out with an eraser, so that you can adjust a pose and make corrections. Blocking-in is an invaluable step in many situations, such as when drawing a full-body pose that is difficult in terms of balance, when drawing a character's signature pose, or when trying to fit multiple characters into one frame.

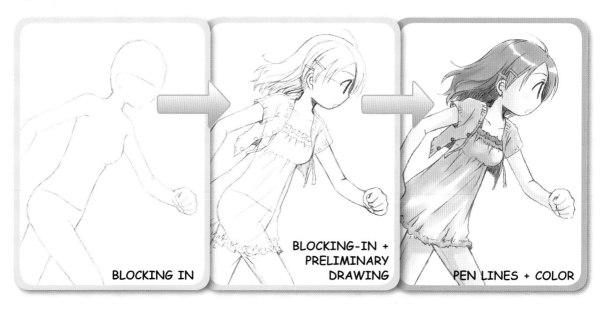

BLOCKING IN

BLOCKING-IN + PRELIMINARY DRAWING

PEN LINES + COLOR

I SEE! SO IF YOU START BY BLOCKING IN A SIMPLE DRAWING, YOU'LL BE ABLE TO DRAW ANY POSE YOU LIKE!

WELL, THAT'S WHAT I THOUGHT, ANYWAY...

CONTINUED ON PAGE 6 5

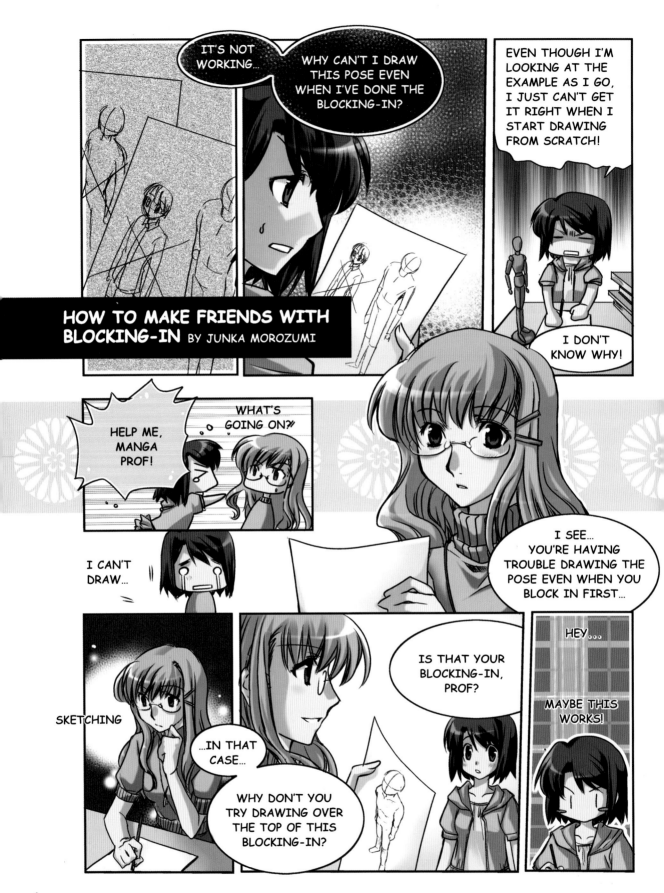

HOW TO MAKE FRIENDS WITH BLOCKING-IN BY JUNKA MOROZUMI

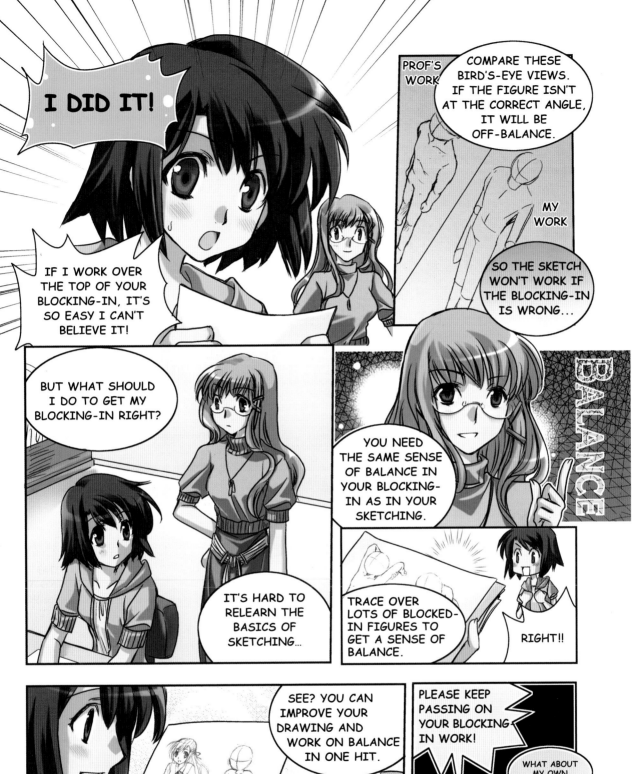
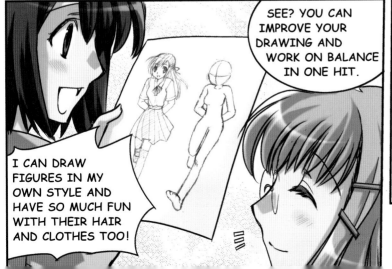

Blocking-in to Get the Balance Right

★ If you get into the habit of starting a drawing of a figure by blocking it in, you'll find the drawing process very smooth. However, even though it looks straightforward, blocking-in can be tricky, and if you get it wrong, the picture itself will be off-balance.

★ The blocking-in on the left is clearly completely off-balance. The head is small, the neck is off-center, the shoulders are at different heights, the limbs and torso are too long, and the hands are too big. these are common errors.

IF THE BALANCE IS WRONG IN THE BLOCKING-IN, IT CAN END UP LOOKING THIS WEIRD...

AGGH!

HOW DO I DEVELOP A SENSE OF BALANCE?

In figure sketching, the aim is to depict the human form accurately. The manga form, however, uses exaggerated expressions and gestures. So when sketching for manga, it's crucial to draw as many "manga-like" poses as possible. A "sense of balance" will come not from thinking too much about it, but rather from drawing figures over and over. One way to practice is to copy illustrations done by professional manga artists. So first of all, take a close look at the work of a manga artist you like and try copying it.

BUT IF I JUST KEEP COPYING A MANGA ARTIST'S WORK, I'LL END UP AS A MERE COPYCAT...

IT'S OK!

I'LL SHOW YOU HOW TO USE COPYING TO DRAW YOUR OWN ORIGINAL WORKS AND PRACTICE GETTING THE BALANCE RIGHT!

★ In this book, you'll find lots of examples of well-balanced blocked-in figures for manga sketches. There's no need to stick rigidly to these examples — you can change the hairstyles, clothing, expressions and so on as you practice drawing various poses. Draw as much as you can to master balance and get the knack of drawing a full-length figure!!

How to Trace Blocking-in

⭐ Broadly speaking, there are two different ways to trace over blocking-in. The first is to trace directly over the blocking lines, while the other involves tracing slightly inside (or outside) the blocking lines. Choose which method is right for your illustration style and give it a go.

HEAD SIZE

IN THESE VERSIONS, THE FACE IS TRACED DIRECTLY OVER THE BLOCKING LINES. THE SIZE OF THE FACE IS THE SAME AS THE BLOCKED-IN SHAPE.

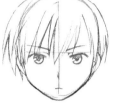

▲ GOOD FOR CUTE CHARACTERS

IN THESE VERSIONS, THE FACE IS TRACED SLIGHTLY WITHIN THE BLOCKING LINES, RESULTING IN A SMALLER FACE. THE EARS FIT WITHIN THE BLOCKING LINES.

▲ GOOD FOR ADULT-LOOKING CHARACTERS

★ HUMOROUS ILLUSTRATIONS, CHILDREN, ETC

MAKE THE FACE BROADER THAN THE BLOCKING LINES.

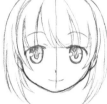

★ ON AN ANGLE, FROM ABOVE

THE BLOCKING LINES CURVE ACROSS THE FACE.

★ ON AN ANGLE, FROM BELOW

TAKE CARE WITH THE DIRECTION OF THE CURVES.

BODY LINES

★ TRACING OVER THE BLOCKING LINES MAKES FOR A STURDY FIGURE.

★ TRACING INSIDE THE NECK AND SHOULDER BLOCKING-IN LINES CREATES A SLIM BUILD.

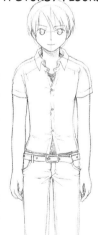

BLOCKING-IN

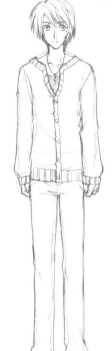

★ BODY BUILD LOOKS DIFFERENT DEPENDING ON WHETHER YOU TRACE DIRECTLY OVER THE BLOCKING LINES OR NOT.

SAMPLE ILLUSTRATIONS 1

SEE PAGE 34

THE VARIATIONS ARE ENDLESS!

★ NO TWO PEOPLE STARTING WITH THE SAME BLOCKED-IN FIGURE WILL COME UP WITH THE SAME RESULT. THERE'S NO END TO THE VARIATIONS THAT CAN BE ACHIEVED. THE MORE YOU DRAW, THE GREATER THE VARIETY OF CHARACTERS YOU CAN COME UP WITH.

◀ POSE 1

GETTING ANGRY WITH HANDS ON HIPS

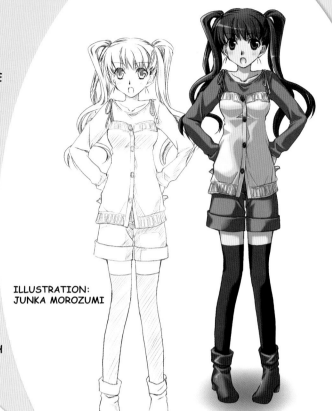

ILLUSTRATION: JUNKA MOROZUMI

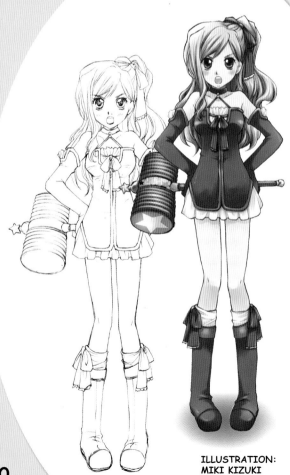

ILLUSTRATION: MIKI KIZUKI

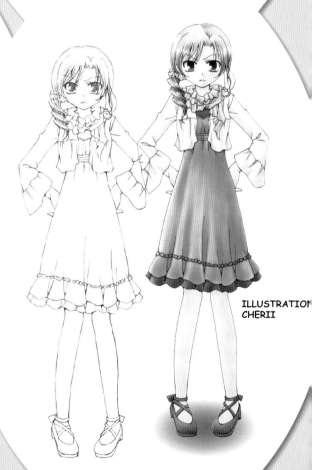

ILLUSTRATION CHERII

DEFINE YOUR CHARACTER

★ THINK ABOUT YOUR CHARACTER. HOW OLD ARE THEY, WHERE ARE THEY FROM, WHAT ERA ARE THEY LIVING IN, WHAT ARE THEIR SPECIAL MOVES AND SO ON? ADAPT THEIR HAIRSTYLE AND OUTFIT AS YOU WORK TO DEFINE THEM.

SEE PAGE 27

◀ POSE 2

RUNNING (MALE)

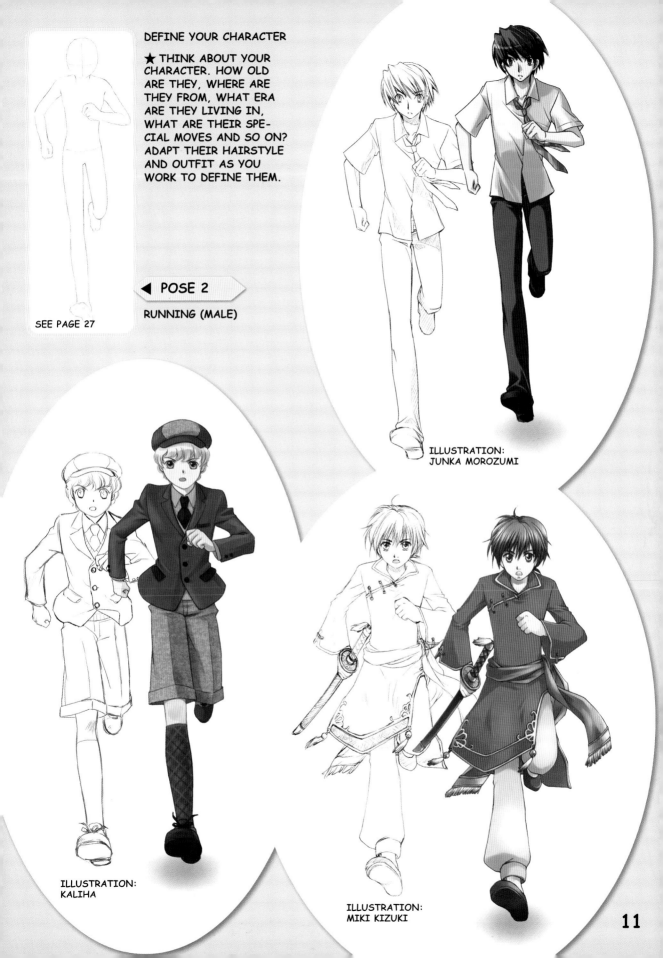

ILLUSTRATION:
JUNKA MOROZUMI

ILLUSTRATION:
KALIHA

ILLUSTRATION:
MIKI KIZUKI

11

★ STORY MANGA

When you're drafting a manga story, start by using pencil to block in the figures. On these pages, you can compare professional manga artists' finished drawings with their blocking-in.

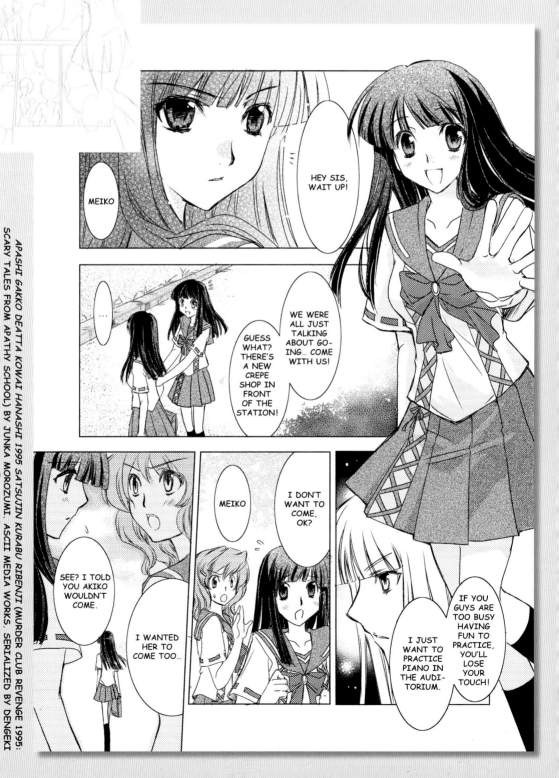

APASHI GAKKO DEATTA KOWAI HANASHI 1995 SATSUJIN KURABU RIBENJI (MURDER CLUB REVENGE 1995: SCARY TALES FROM APATHY SCHOOL) BY JUNKA MOROZUMI. ASCII MEDIA WORKS. SERIALIZED BY DENGEKI ONLINE. © SHANON LTD/NANA KOROBI HACHIOKI/IIJIMA TAKIYA

★ COMIC STRIPS

Just as for story manga, comic strips begin with the process of blocking-in. Use this stage to work out the size of each character in the frame and so on.

CHO! EDO BAKUMATSUDEN (SUPER EDO ERA) BY TOMOMI MIZUNA. SERIAL-IZED BY MANGA TIME JUMBO. © HOUBUNSHA

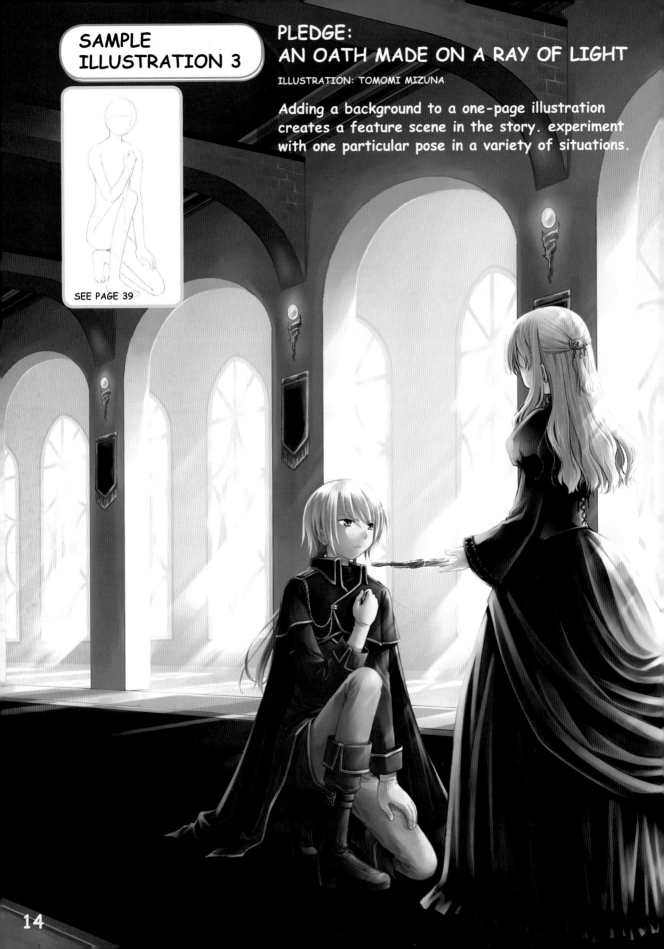

SAMPLE ILLUSTRATION 3

SEE PAGE 39

PLEDGE: AN OATH MADE ON A RAY OF LIGHT

ILLUSTRATION: TOMOMI MIZUNA

Adding a background to a one-page illustration creates a feature scene in the story. experiment with one particular pose in a variety of situations.

COLLEGE OF MAGIC: THE SUMMONS

ILLUSTRATION: JUNKA MOROZUMI

It's fine to combine two blocked-in figures to create a single illustration too. How the poses come across can change completely depending on how they are put together.

SEE PAGE 42 SEE PAGE 41

HOW TO USE THIS BOOK

YOU CAN DRAW DIRECTLY OVER THE PICTURES IN THIS BOOK TO PRACTICE.

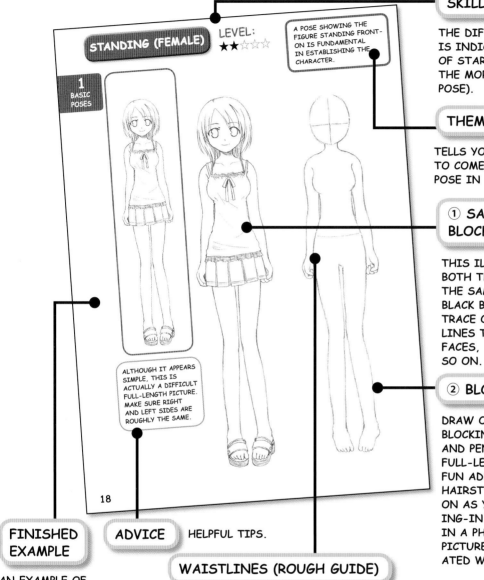

STANDING (FEMALE)

LEVEL:
★★☆☆☆

A POSE SHOWING THE FIGURE STANDING FRONT-ON IS FUNDAMENTAL IN ESTABLISHING THE CHARACTER.

1 BASIC POSES

ALTHOUGH IT APPEARS SIMPLE, THIS IS ACTUALLY A DIFFICULT FULL-LENGTH PICTURE. MAKE SURE RIGHT AND LEFT SIDES ARE ROUGHLY THE SAME.

18

SKILL LEVEL

THE DIFFICULTY OF EACH POSE IS INDICATED BY THE NUMBER OF STARS (THE MORE STARS, THE MORE DIFFICULT THE POSE).

THEME

TELLS YOU WHEN YOU ARE LIKELY TO COME ACROSS THIS KIND OF POSE IN A MANGA.

① SAMPLE AND BLOCKED-IN FIGURE

THIS ILLUSTRATION SHOWS BOTH THE COLORED LINES OF THE SAMPLE DRAWING AND THE BLACK BLOCKING-IN LINES. TRACE OVER THE COLORED LINES TO STUDY HOW TO DRAW FACES, HAIR, CLOTHING AND SO ON.

② BLOCKING-IN

DRAW OVER THE COLORED BLOCKING-IN LINES IN PENCIL AND PEN TO CREATE YOUR OWN FULL-LENGTH FIGURES. HAVE FUN ADDING YOUR FAVOURITE HAIRSTYLES, CLOTHING AND SO ON AS YOU WORK! THE BLOCK-ING-IN LINES WILL DISAPPEAR IN A PHOTOCOPY, SO ONLY THE PICTURE THAT YOU HAVE CRE-ATED WILL SHOW.

FINISHED EXAMPLE

AN EXAMPLE OF THE FINISHED DRAWING. HOW DOES IT COMPARE TO YOURS?

ADVICE
HELPFUL TIPS.

WAISTLINES (ROUGH GUIDE)

THE WAISTLINES OF THE BLOCKED-IN FIGURES ARE SET AT AN AVERAGE HEIGHT, SO USE THEM AS A GUIDE WHEN DRAWING CLOTHING.

JEANS, ETC (DRAW THE BELT DIRECTLY OVER THE BLOCKING-IN LINE)

FORMAL SUITS, ETC (DRAW THE BELT ABOVE THE BLOCKING-IN LINE)

HIP-HANGER SKIRTS, ETC (DRAW THE BELT BELOW THE BLOCKING-IN LINE)

LET'S GET STARTED WITH THE BASIC POSES!

Chapter 1

Basic Poses

A POSE SHOWING THE FIGURE STANDING FRONT-ON IS FUNDAMENTAL IN ESTABLISHING THE CHARACTER.

1
BASIC POSES

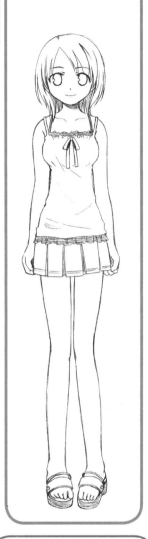

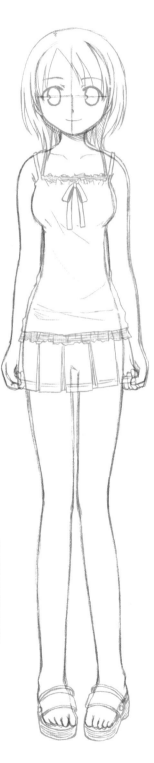

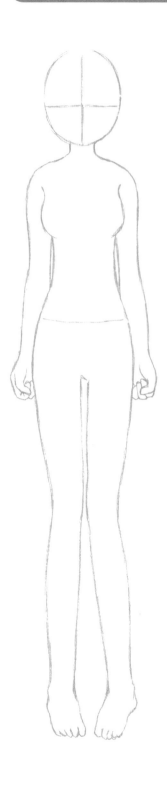

ALTHOUGH IT APPEARS SIMPLE, THIS IS ACTUALLY A DIFFICULT FULL-LENGTH PICTURE. MAKE SURE RIGHT AND LEFT SIDES ARE ROUGHLY THE SAME.

STANDING (MALE)

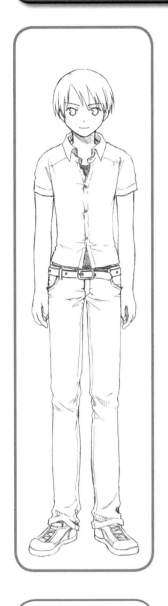

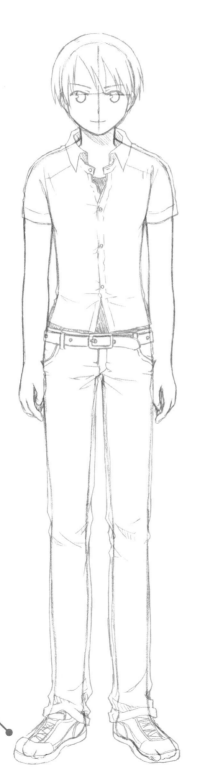

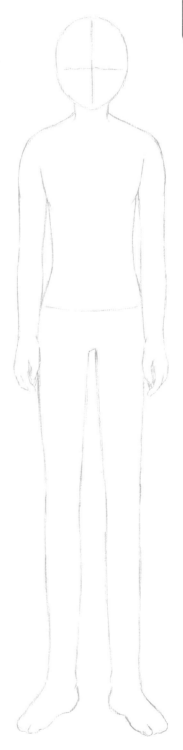

THE KEY POINT WHEN DRAWING MALE FEET IS TO MAKE THEM LARGE AND PLANTED FIRMLY ON THE GROUND.

STANDING, SIDE VIEW (FEMALE)

LEVEL: ★★★☆☆

WHEN SHOWN SIDE-ON, THE FULLNESS OF THE FIGURE BECOMES EVIDENT. TAKE CARE NOT TO DRAW THE BODY SO IT APPEARS FLAT.

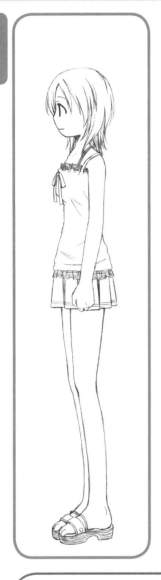

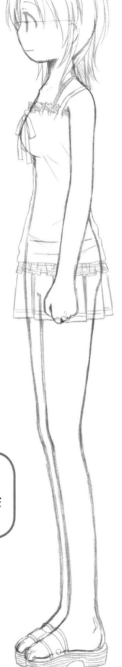

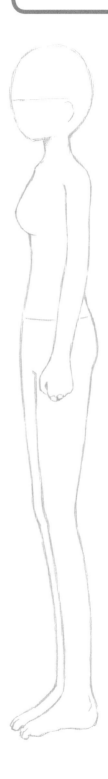

* USE CURVED LINES TO DRAW IN THE AREA FROM THE NECK TO THE CHEST AND STOMACH.

STANDING, SIDE VIEW (MALE)

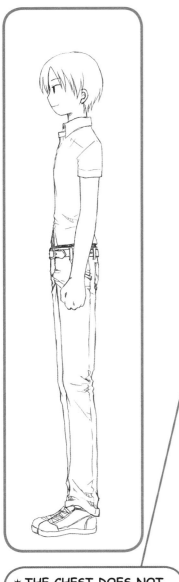

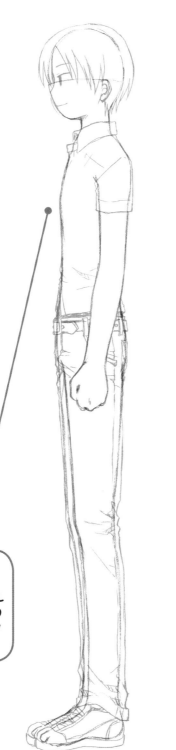

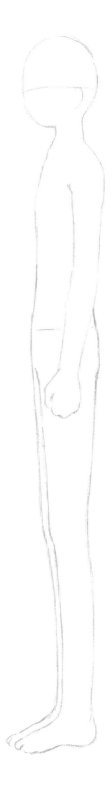

* THE CHEST DOES NOT PROTRUDE AS MUCH AS THE FEMALE'S, BUT STILL HAS SOME FULLNESS, SO DON'T FORGET TO SHOW THIS.

WALKING (FEMALE)

LEVEL:
★★★☆☆

THIS IS THE STARTING POINT FOR PRACTICING POSES DEPICTING MOVEMENT. THE LEGS SEPARATE SO THAT ONE IS IN FRONT OF THE OTHER, BRINGING OUT DEPTH.

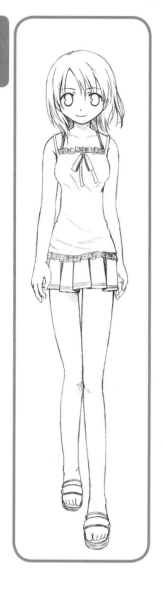

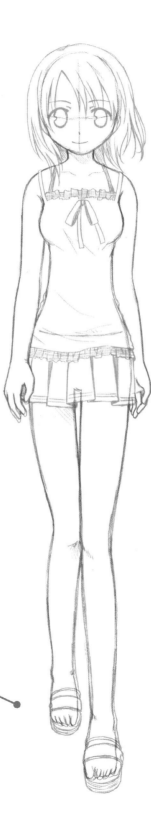

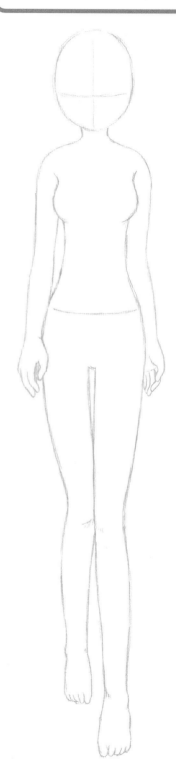

∗ DRAWING THE FEET TO FACE SLIGHTLY INWARDS MAKES FOR A FEMININE APPEARANCE.

WALKING (MALE)

LEVEL:
★★★☆☆

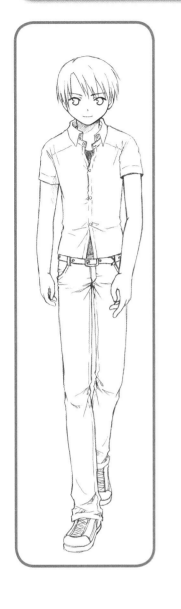

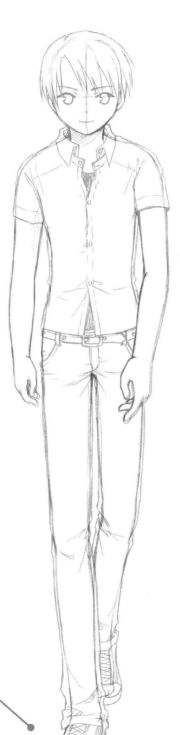

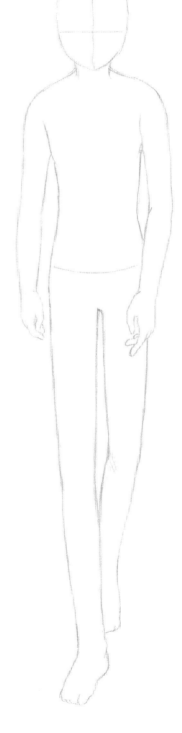

＊ COMPARED TO
FEMALE FEET, THE
FRONT OF MALE FEET
FACE OUTWARDS.

AS YOU CAN'T USUALLY SEE WHAT YOU LOOK LIKE FROM BEHIND, THIS CAN BE DIFFICULT TO DRAW.

1 BASIC POSES

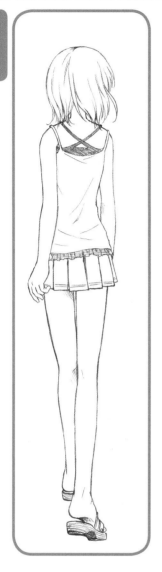

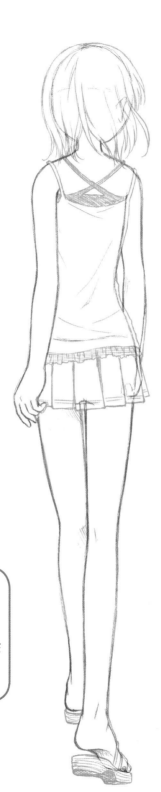

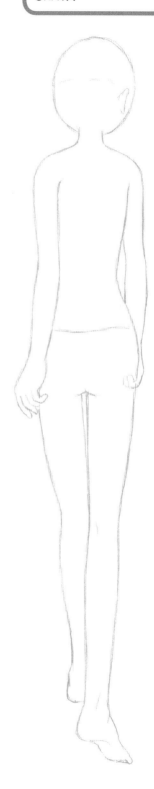

* NOTE HOW THE LEFT SHOULDER MOVES BACKWARD AND THE RIGHT HIP MOVES FORWARD. THE BODY TWISTS WHEN WALKING.

WALKING, REAR VIEW (MALE)

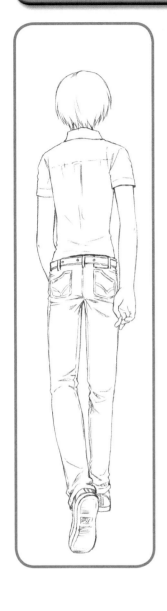

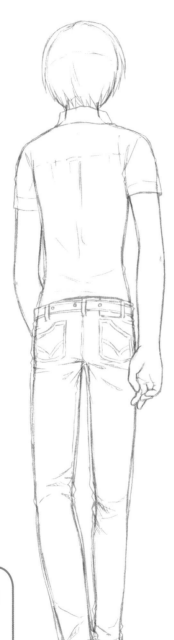

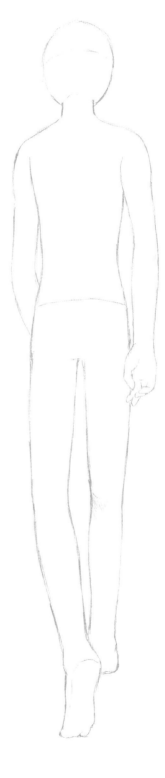

* DRAWING THE
FEET TO REVEAL THE
SOLES CREATES THE
IMPRESSION THAT
THE CHARACTER IS
TAKING LONG STEPS.

RUNNING (FEMALE)

LEVEL:
★★☆☆☆

THIS RUNNING FIGURE CAN BE USED TO ADD A SENSE OF URGENCY TO SITUATIONS OR TO EXPRESS PANIC.

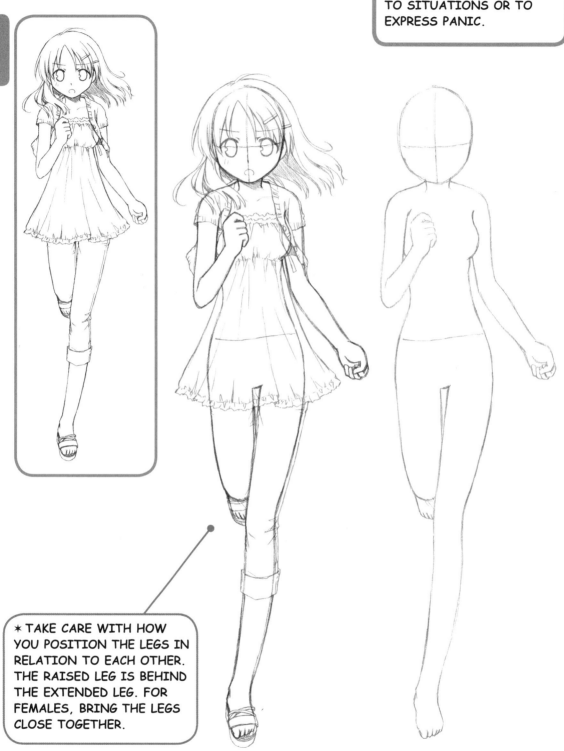

* TAKE CARE WITH HOW YOU POSITION THE LEGS IN RELATION TO EACH OTHER. THE RAISED LEG IS BEHIND THE EXTENDED LEG. FOR FEMALES, BRING THE LEGS CLOSE TOGETHER.

RUNNING (MALE)

LEVEL:
 ★★☆☆☆

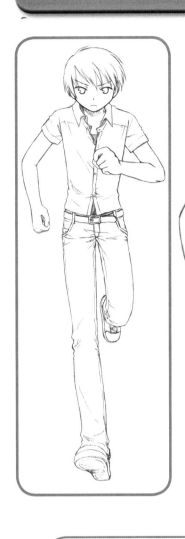

* THE BENT LEG IS BEHIND THE EXTENDED LEG, SO DRAW THE SHOE ON THAT LEG SLIGHTLY SMALLER.

RUNNING, SIDE VIEW (FEMALE)

LEVEL: ★☆☆☆☆

AS THERE IS SO MUCH MOVEMENT IN THE ARMS AND LEGS, YOU MAY FIND THE SIDE VIEW OF SOMEONE RUNNING EASIER TO DRAW THAN THE STRAIGHT-ON VIEW.

1
BASIC POSES

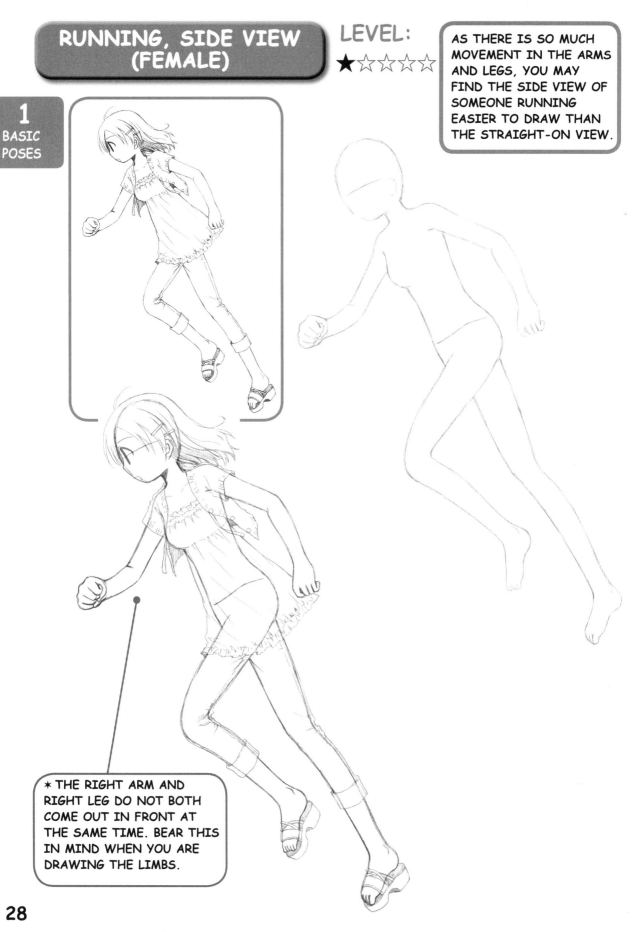

⋆ THE RIGHT ARM AND RIGHT LEG DO NOT BOTH COME OUT IN FRONT AT THE SAME TIME. BEAR THIS IN MIND WHEN YOU ARE DRAWING THE LIMBS.

RUNNING, SIDE VIEW (MALE)

LEVEL:
★☆☆☆☆

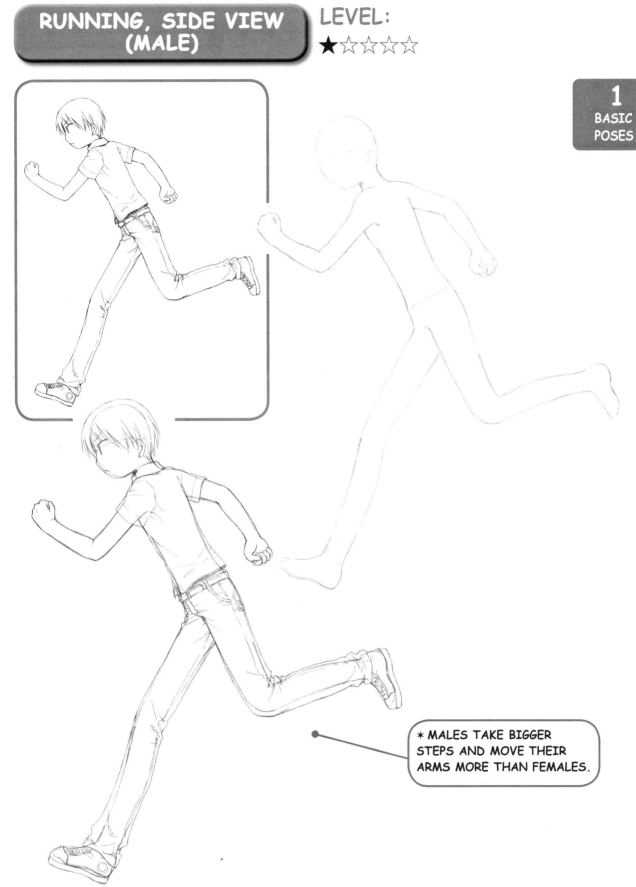

* MALES TAKE BIGGER STEPS AND MOVE THEIR ARMS MORE THAN FEMALES.

29

RUNNING, REAR VIEW (FEMALE)

LEVEL: ★★★★☆

THE ARM OUT IN FRONT IS NOT VISIBLE, SO THE REAR VIEW OF A RUNNING FIGURE IS SLIGHTLY TRICKY TO DRAW.

1 BASIC POSES

* FEMALES DO NOT MOVE THEIR ARMS MUCH, SO USE THE HAIR AND OTHER ELEMENTS OF THE DRAWING TO EXPRESS MOTION.

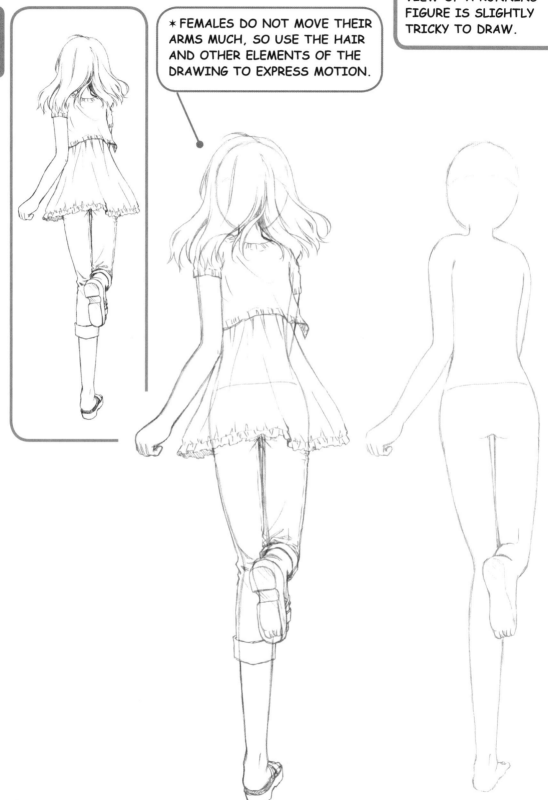

RUNNING, REAR VIEW (MALE)

*WHEN DRAWING MALES, THE TRICK IS TO DEPICT THE ARMS OUT AND AWAY FROM THE BODY IN A STRONG MOVEMENT.

★ People often get confused about the placement of eyes, nose, or eyebrows. But for all characters the positioning of facial features is fairly similar, so when drawing a face, rule in lines at the blocking-in stage as shown below.

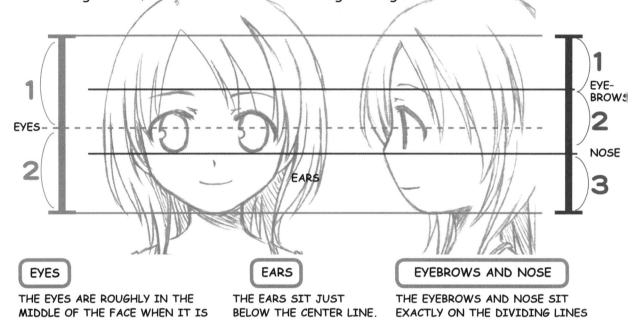

EYES	EARS	EYEBROWS AND NOSE
THE EYES ARE ROUGHLY IN THE MIDDLE OF THE FACE WHEN IT IS DIVIDED IN HALF HORIZONTALLY.	THE EARS SIT JUST BELOW THE CENTER LINE.	THE EYEBROWS AND NOSE SIT EXACTLY ON THE DIVIDING LINES WHEN THE FACE IS DIVIDED INTO THIRDS.

VARIOUS EXPRESSIONS

When drawing full-length poses, bring the character to life by drawing in facial expressions to match. When you are tracing, pay attention to the combination of pose and facial expression.

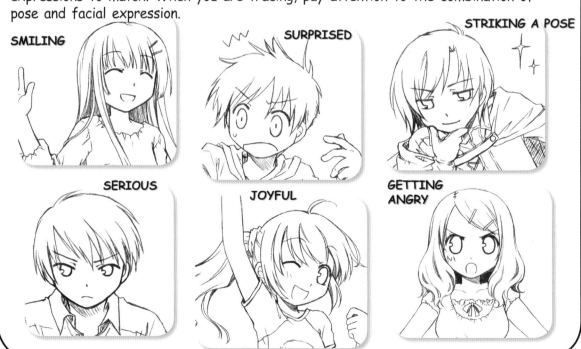

SMILING

SURPRISED

STRIKING A POSE

SERIOUS

JOYFUL

GETTING ANGRY

Chapter 2

Signature
Poses

GETTING ANGRY WITH HANDS ON HIPS

LEVEL: ★★★☆☆

USE THIS POSE FOR FEMALE CHARACTERS WHEN THEY ARE GETTING ANGRY OR TO CONVEY A STRONG CHARACTER.

2 SIGNATURE POSES

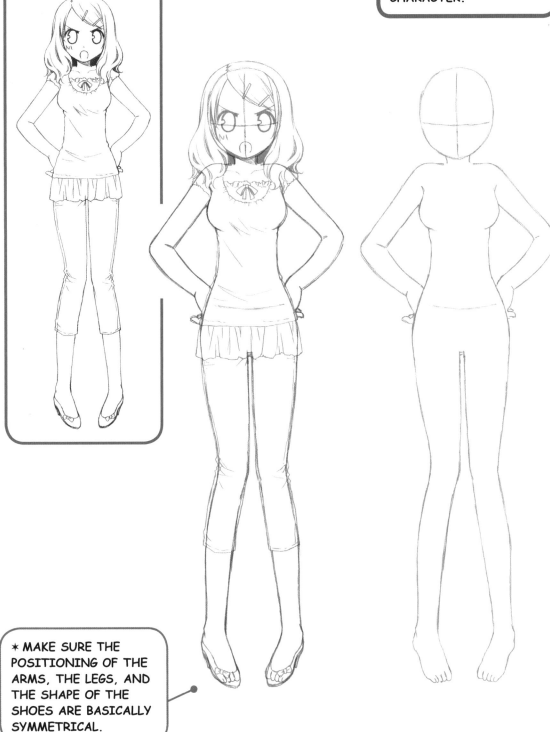

★ MAKE SURE THE POSITIONING OF THE ARMS, THE LEGS, AND THE SHAPE OF THE SHOES ARE BASICALLY SYMMETRICAL.

STRETCHING

LEVEL:
★★☆☆☆

USE THIS POSE TO EXPRESS FATIGUE, A CHANGE IN MOOD OR A LAIDBACK CHARACTER.

* IF YOU'RE NOT CAREFUL, THE BENT ARM MAY END UP BEING TOO LONG, SO WATCH OUT FOR THIS.

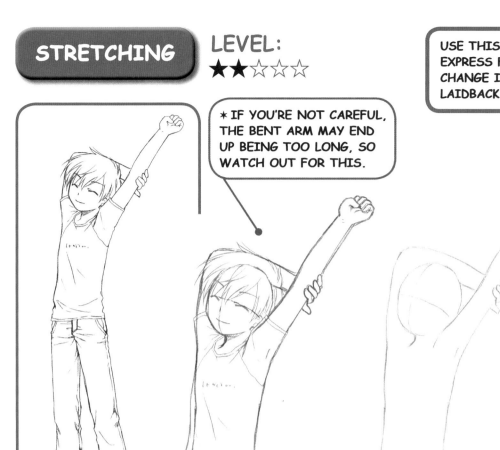

THIS IS A SIGNATURE POSE FOR MALE CHARACTERS. IT MIGHT BE MORE SUITED FOR COMICAL CHARACTERS THAN HANDSOME CHARACTERS.

* DRAWING THE FACE TILTING DOWN ADDS TO THE FEELING THAT THE HAND IS SUPPORTING THE CHIN.

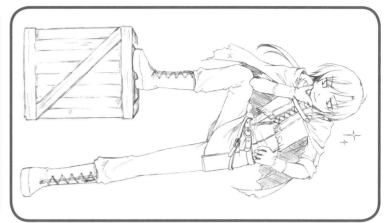

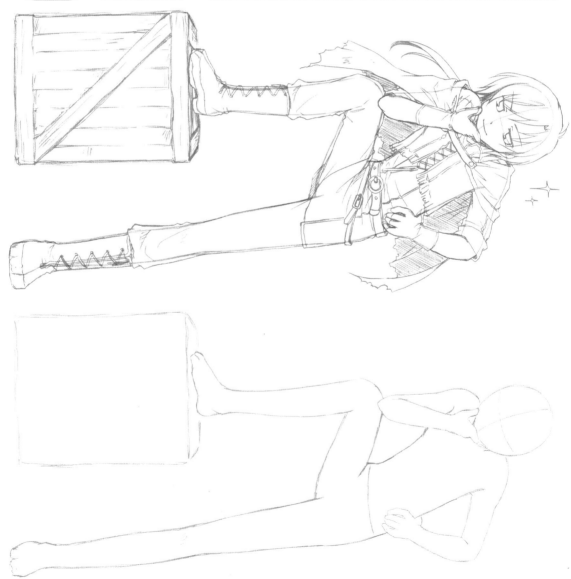

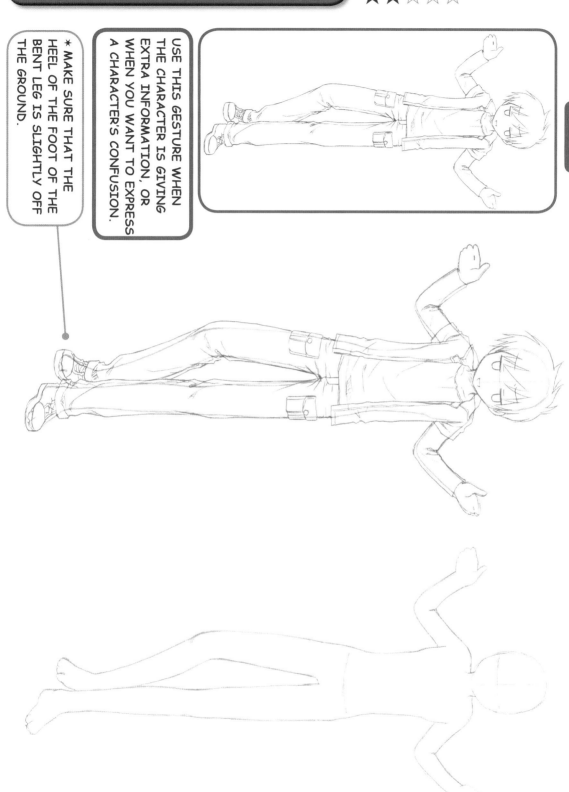

USE THIS GESTURE WHEN THE CHARACTER IS GIVING EXTRA INFORMATION, OR WHEN YOU WANT TO EXPRESS A CHARACTER'S CONFUSION.

* MAKE SURE THAT THE HEEL OF THE FOOT OF THE BENT LEG IS SLIGHTLY OFF THE GROUND.

2
SIGNATURE
POSES

WAVING

LEVEL: ★★★☆☆

THIS IS AN EXPRESSION FOR A CHEERFUL FEMALE CHARACTER. IT'S ALSO SUITED FOR A CHARACTER'S FIRST APPEARANCE.

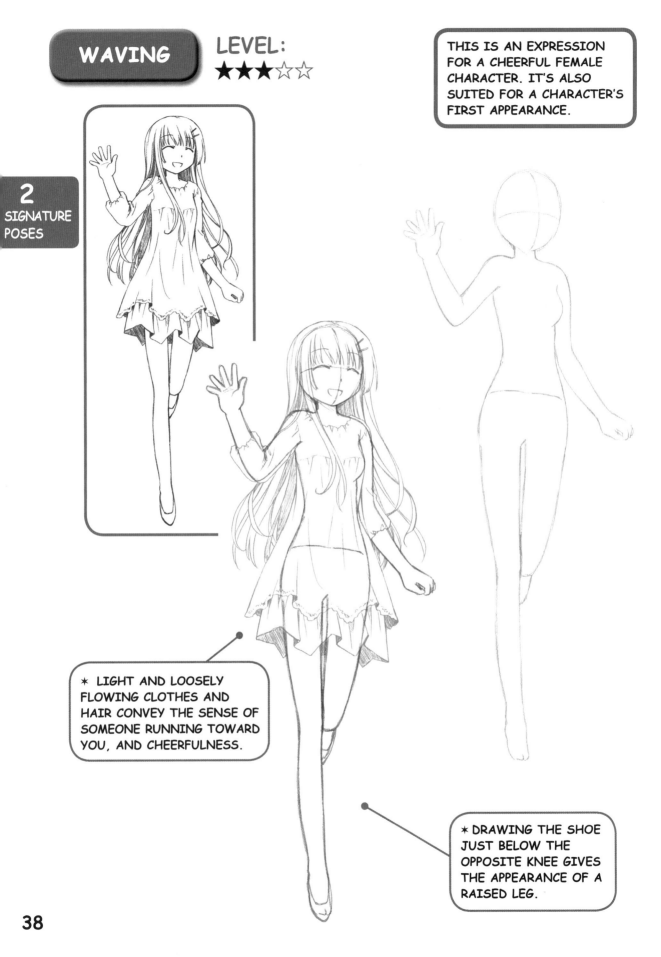

✳ LIGHT AND LOOSELY FLOWING CLOTHES AND HAIR CONVEY THE SENSE OF SOMEONE RUNNING TOWARD YOU, AND CHEERFULNESS.

✳ DRAWING THE SHOE JUST BELOW THE OPPOSITE KNEE GIVES THE APPEARANCE OF A RAISED LEG.

GOING DOWN ON ONE KNEE

LEVEL:
★★★★★

THIS POSE CAN BE
USED IN A SCENE
WHERE A KNIGHT
IS PLEDGING
LOYALTY OR FOR
A ROMANTIC
PROPOSAL.

2
SIGNATURE
POSES

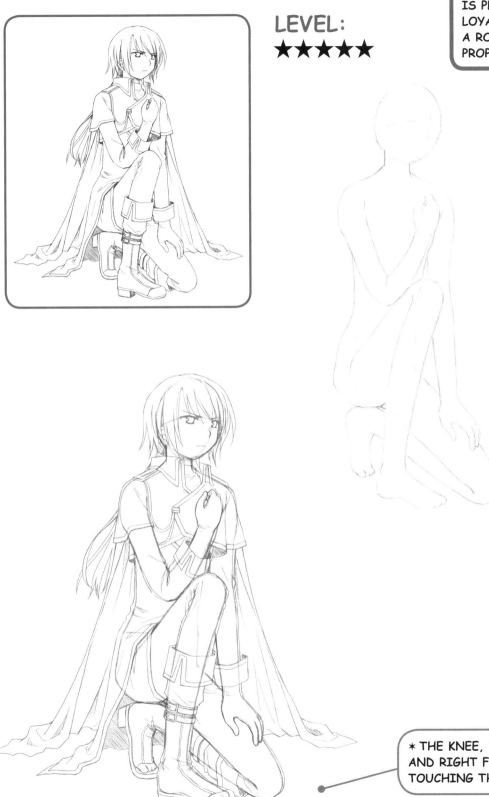

* THE KNEE, TIPS OF TOES
AND RIGHT FOOT ARE ALL
TOUCHING THE GROUND.

SHOWING SURPRISE

LEVEL: ★★★☆☆

THIS IS THE PERFECT EXPRESSION FOR A COMICAL CHARACTER.

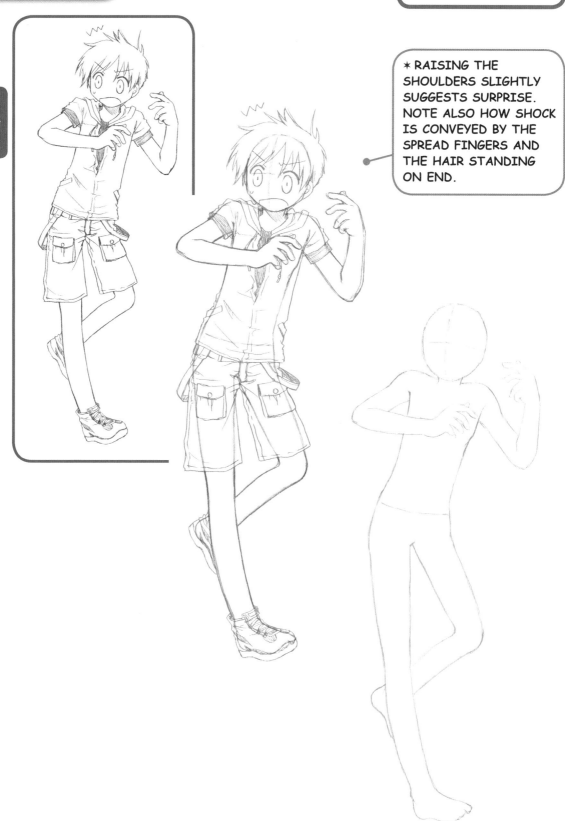

* RAISING THE SHOULDERS SLIGHTLY SUGGESTS SURPRISE. NOTE ALSO HOW SHOCK IS CONVEYED BY THE SPREAD FINGERS AND THE HAIR STANDING ON END.

JUMPING

LEVEL: ★★★★☆

THIS IS A POSE FULL OF ENERGY. IT WOULD SUIT EXCLAMATIONS SUCH AS "YAY!" AND "WOOHOO!!"

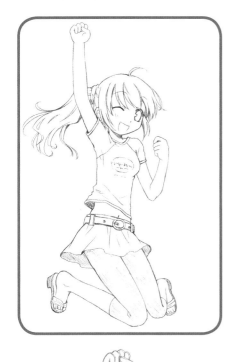

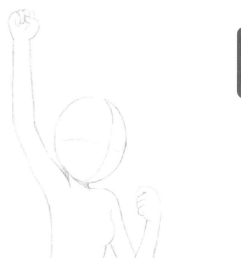

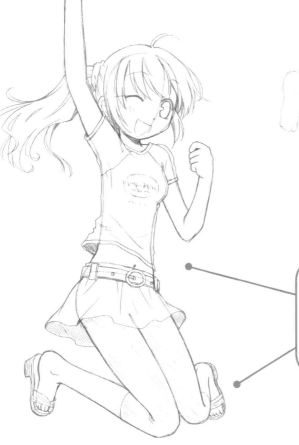

* SHOWING JUST A LITTLE OF THE STOMACH WORKS WELL TO CONVEY THE MOMENTUM OF THE JUMP. THE CALF IS SHORT TO GIVE DEPTH TO THE DRAWING.

HIP-HOP STYLE JUMPING

LEVEL: ★★★★☆

THIS POSE IS GREAT FOR ENERGETIC, ENTHUSIASTIC CHARACTERS WHO ARE FULL OF LIFE. IT CAN ALSO BE USED FOR SPORTS SUCH AS SKATEBOARDING AND SNOWBOARDING.

2
SIGNATURE POSES

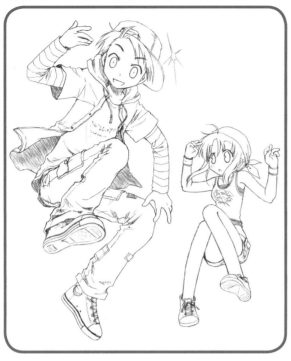

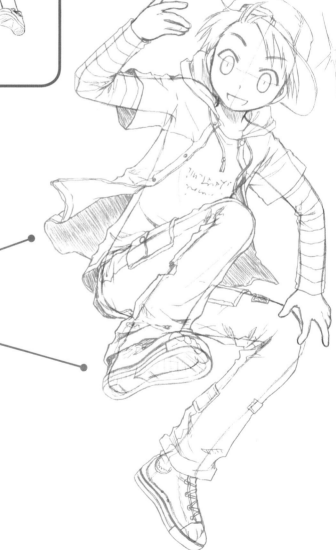

* ADDING MOVEMENT TO THE HAIR AND CLOTHING EMPHASIZES THE JUMPING ACTION. MAKING THE LEG IN FRONT BIGGER BRINGS OUT THE FORCE OF THE MOVEMENT.

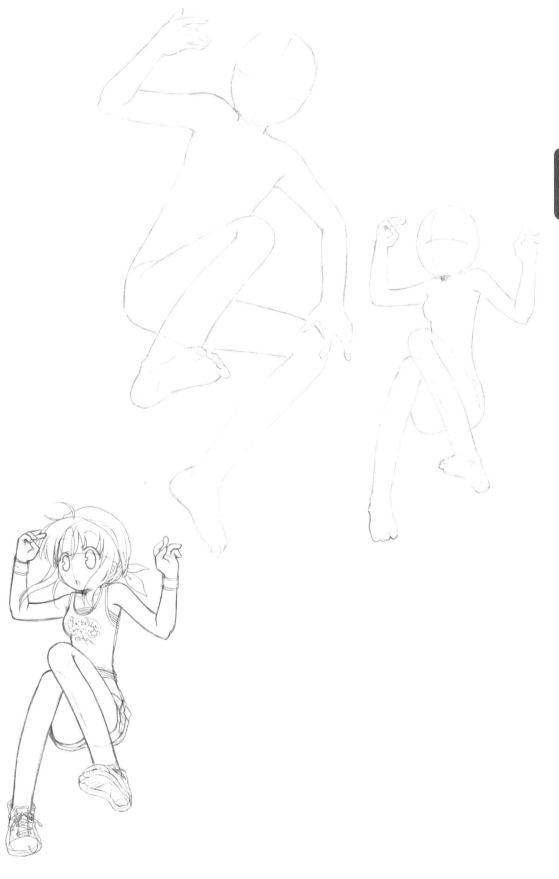

PLACING BOTH HANDS ON KNEES

LEVEL: ★★★★☆

USE THIS POSE TO EXPRESS FATIGUE, TAKING A REST, AND DISAPPOINTMENT.

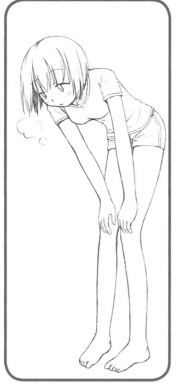

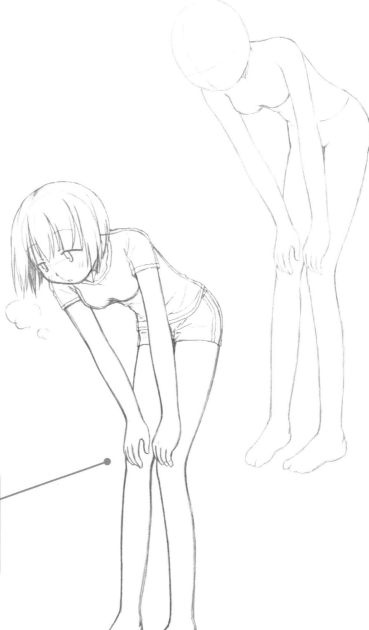

* SO THAT BOTH HANDS SIT PERFECTLY OVER THE KNEES, TAKE INTO ACCOUNT THE LENGTH OF THE ARMS, TORSO AND THIGHS AS YOU DRAW.

HANDS BEHIND THE HEAD

LEVEL:
★★★☆☆

THIS IS A FEMININE SIGNATURE POSE. IT CAN ALSO BE USED IN SCENES WHERE THE CHARACTER IS JUST WAKING UP.

* THE ARMS CLASPED BEHIND THE HEAD ARE NOT VISIBLE, BUT IF YOU DRAW THEM IN FAINTLY AT THE BLOCKING-IN STAGE, IT WILL HELP YOU GET THE LENGTH RIGHT.

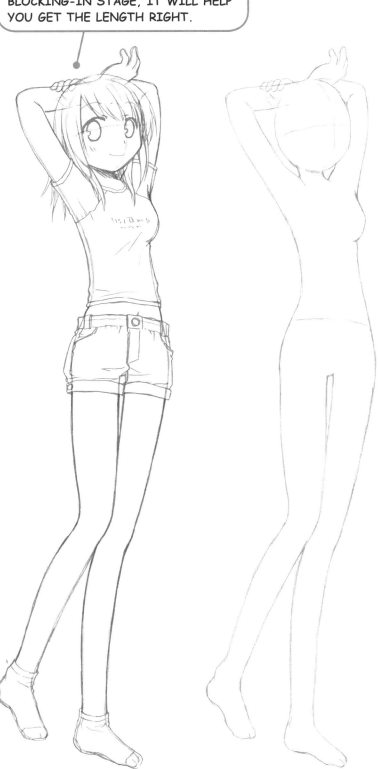

45

TURNING AROUND

THIS CAN BE USED IN A SNAPSHOT-TYPE DRAWING FOR A CUTE CHARACTER, OR AS A FULL PAGE ILLUSTRATION.

2
SIGNATURE POSES

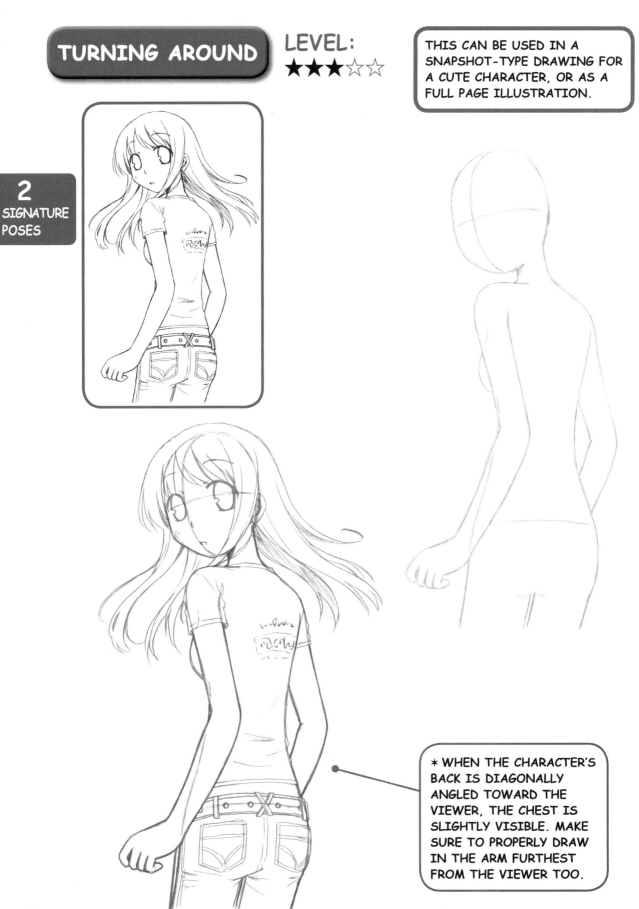

* WHEN THE CHARACTER'S BACK IS DIAGONALLY ANGLED TOWARD THE VIEWER, THE CHEST IS SLIGHTLY VISIBLE. MAKE SURE TO PROPERLY DRAW IN THE ARM FURTHEST FROM THE VIEWER TOO.

FLIPPING HAIR

LEVEL:
★★★☆☆

THIS POSE IS GOOD FOR CONVEYING FEMININITY AND MATURITY. IT ALSO WORKS WELL FOR A PROUD, PRINCESS-LIKE CHARACTER.

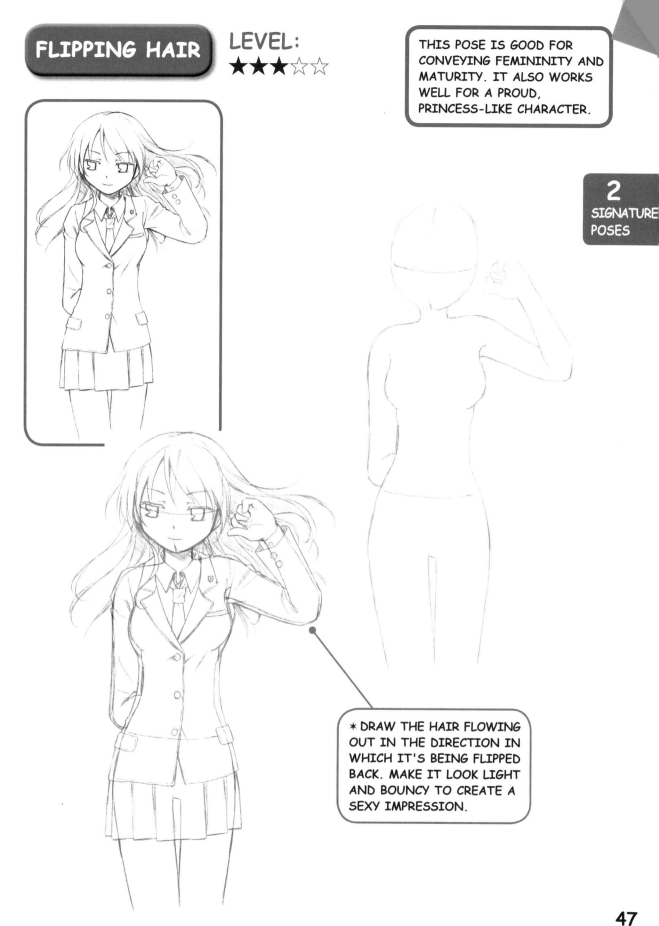

∗ DRAW THE HAIR FLOWING OUT IN THE DIRECTION IN WHICH IT'S BEING FLIPPED BACK. MAKE IT LOOK LIGHT AND BOUNCY TO CREATE A SEXY IMPRESSION.

★ 2 ...
HOW TO DRAW HAIR

★ When drawing hair, make it sit out from the head and create volume at the crown. Hair should feel light and look natural. Lank hair lying flat on the head makes for a lifeless character.

NOTE THE MOVEMENT OF HAIR

When drawing action poses, hair can be used to enhance the expression of the body, creating a more realistic impression. Hair can show which direction the body is moving in, as well as speed and force. Draw hair that matches your character's movement.

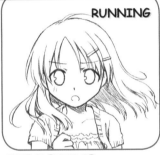

RUNNING

GIVE PLENTY OF MOVEMENT TO THE HAIR!

JUMPING 1

MAKE THE HAIR SWING TO ADD TO THE FEELING OF MOVEMENT!

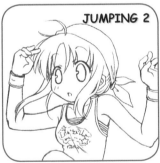

JUMPING 2

THE CHARACTER IS IN MID-AIR, SO MAKE THE HAIR LIGHT AND BOUNCY.

TURNING AROUND

THE HAIR SHOULD SWEEP OUT IN TWO DIRECTIONS.

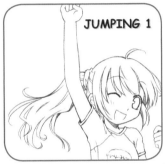

FLIPPING HAIR

MAKE THE HAIR LOOK SLEEK AND SMOOTH.

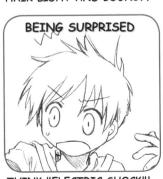

BEING SURPRISED

THINK "ELECTRIC SHOCK"!

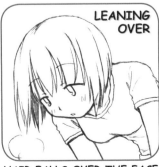

LEANING OVER

HAIR FALLS OVER THE FACE

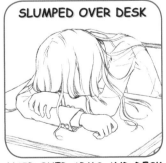

SLUMPED OVER DESK

HAIR OVER ARMS AND DESK.

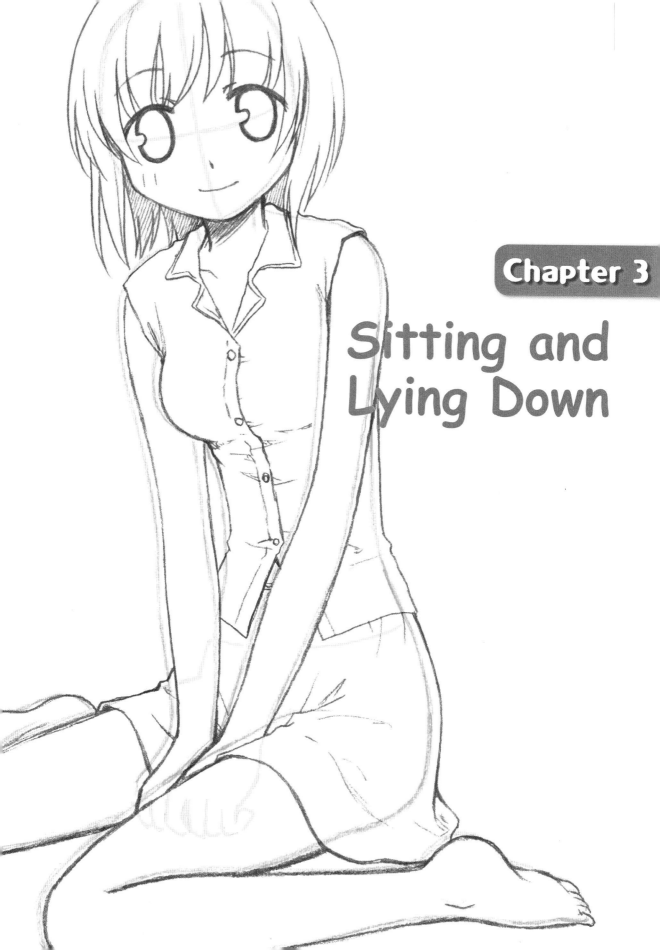

Chapter 3

Sitting and
Lying Down

SITTING IN A CHAIR (FEMALE)

LEVEL: ★★★☆☆

THIS POSE APPEARS OFTEN BOTH AS A SCENE FROM EVERYDAY LIFE AND AS A SIGNATURE POSE.

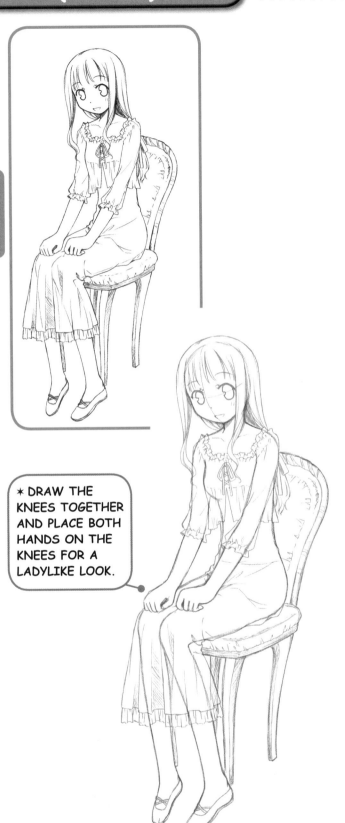

* DRAW THE KNEES TOGETHER AND PLACE BOTH HANDS ON THE KNEES FOR A LADYLIKE LOOK.

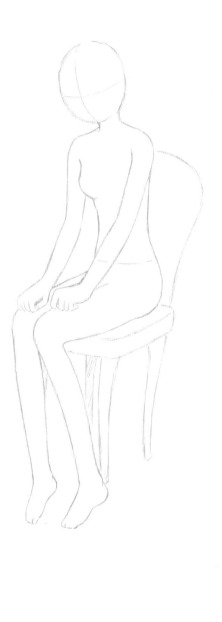

SITTING IN A CHAIR (MALE)

LEVEL: ★★★☆☆

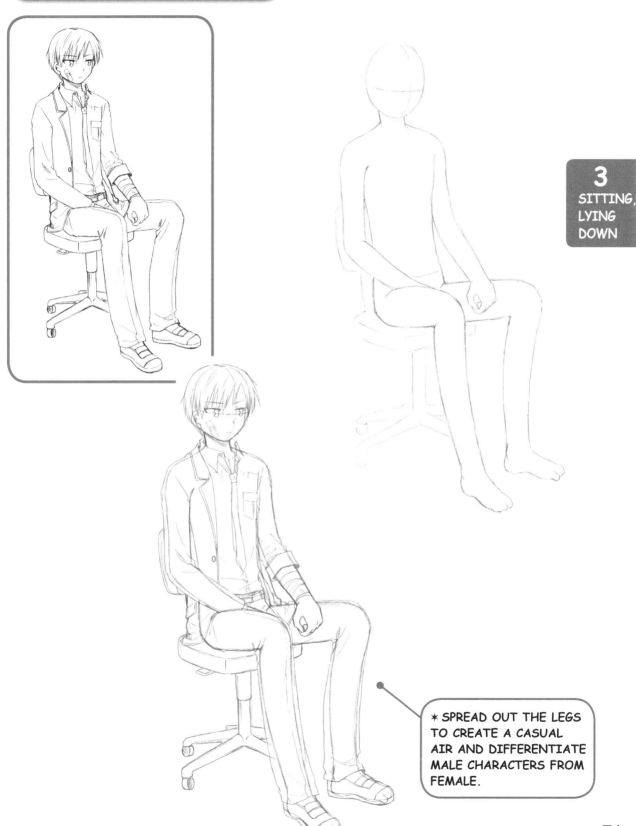

* SPREAD OUT THE LEGS TO CREATE A CASUAL AIR AND DIFFERENTIATE MALE CHARACTERS FROM FEMALE.

SITTING IN A CHAIR WITH LEGS CROSSED

LEVEL: ★★★★☆

THIS CREATES A MATURE, FEMININE LOOK THAT SUITS A CAREER-WOMAN CHARACTER.

3
SITTING, LYING DOWN

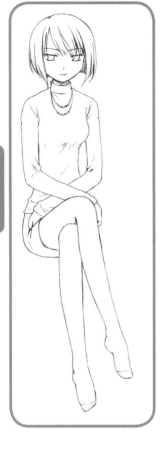

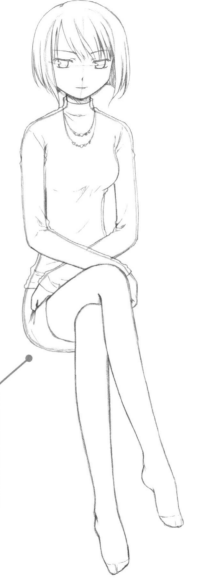

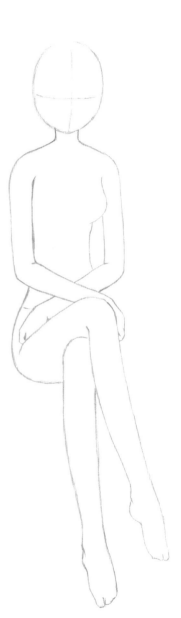

∗ PAY ATTENTION TO THE WAY THE LEGS SIT ONE OVER THE OTHER IN THIS CROSS-LEGGED POSE. BECAUSE THE CHARACTER IS FRONT ON, THE THIGH APPEARS SHORTER.

SITTING ON THE FLOOR IN A FORMAL POSITION

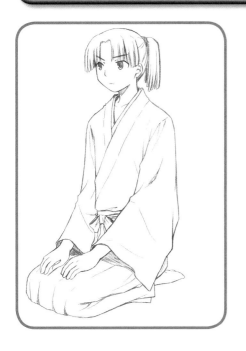

LEVEL:
★★★☆☆

THIS FORMAL SEATED POSE IS INVALUABLE FOR SCENES IN A TATAMI ROOM, FOR PERIOD DRAMAS, DEPICTING MENTAL CONCENTRATION, AND FOR TRADITIONAL JAPANESE SCENES.

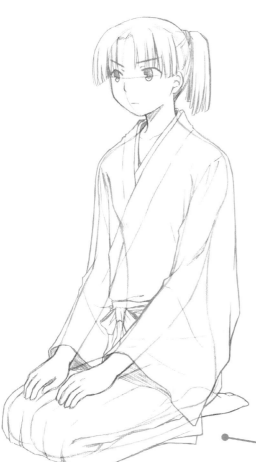

* WHEN DRAWING THE BLOCKED-IN FIGURE, MAKE SURE YOU DRAW IN THE CONCEALED SECTION OF THE LEGS BELOW THE KNEES TO PREVENT THE LEGS FROM BE-ING FLATTENED OUT.

SITTING ON THE FLOOR HUGGING THE KNEES

LEVEL: ★★☆☆☆

THIS POSE CAN SHOW A CHARACTER RELAXING AT HOME, SITTING IN A CIRCLE OF PEOPLE TALKING, OR TAKING PART IN A PHYSICAL EDUCATION CLASS OR SOME OTHER SPORTING ACTIVITY.

3
SITTING, LYING DOWN

* THE BACK IS SLIGHTLY ROUNDED. NOTE THAT THE BODY TOUCHES THE GROUND IN THREE PLACES: THE BUTTOCKS AND BOTH FEET. MAKE SURE THE ANGLE AND SLOPE OF THE CHARACTER'S BACK FIT WITH THE PLACEMENT OF THE BUTTOCKS ON THE FLOOR.

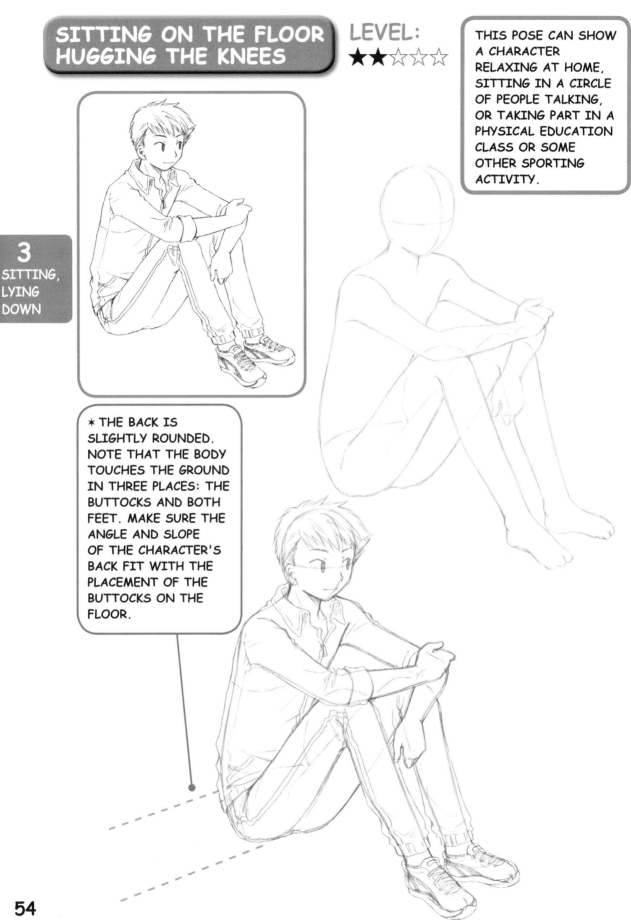

SITTING CROSS-LEGGED ON THE FLOOR

LEVEL:
★★★☆☆

A RELAXED POSE SUITED TO SIT-UATIONS WHERE CHARACTERS ARE DRINKING TOGETHER, HAVING A PARTY AT HOME AND SO ON.

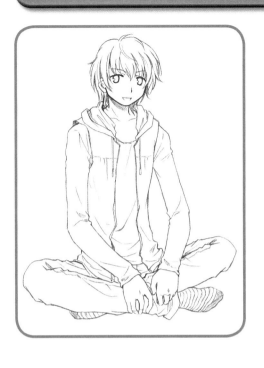

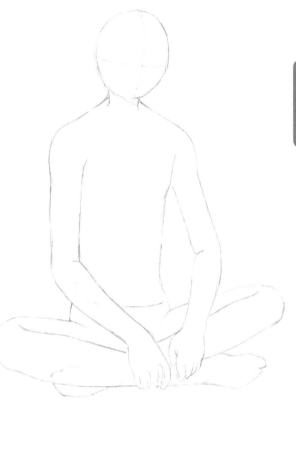

3
SITTING, LYING DOWN

* TAKE CARE NOT TO LET THE LEGS GET TOO LONG WHEN THEY'RE CROSSED. ALLOW FOR DEPTH AND KEEP THEM QUITE SHORT.

SITTING ON THE FLOOR WITH ONE KNEE RAISED

LEVEL:
★★★☆☆

THIS IS A CHILLED-OUT POSE THAT CAN ALSO WORK FOR WHEN THE CHARACTER IS TRYING TO LOOK COOL.

3
SITTING, LYING DOWN

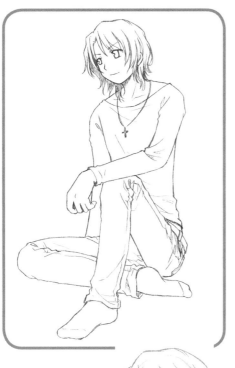

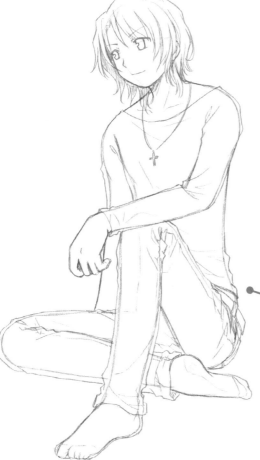

* MAKE SURE THE UPRIGHT LEG ISN'T TOO LONG AND THE KNEE ISN'T TOO HIGH. THE SUPPORTING HAND SHOULD BE TOUCHING THE GROUND.

SITTING WITH LEGS TO ONE SIDE

LEVEL:
★★☆☆☆

AN ULTRA-FEMININE POSE. IF YOU DRAW A WALL BEHIND THE FIGURE, YOU CAN USE THE POSE FOR A SLEEPY OR DROWSY SCENE.

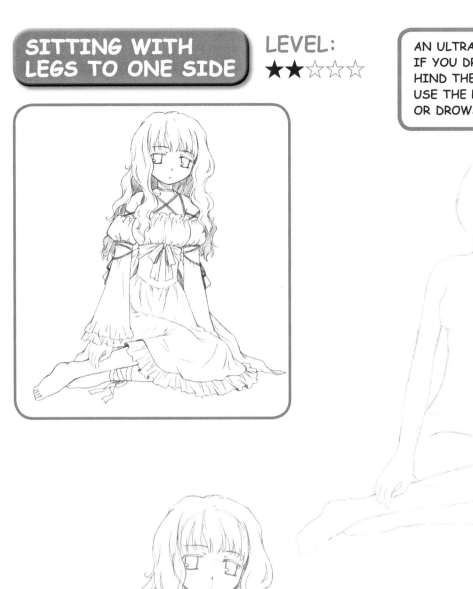

* NOTE THAT THE LEFT AND THE RIGHT KNEE DON'T MEET. IF THEY ARE LINED UP PERFECTLY, THIS WILL MAKE THE POSITION LOOK UNNATURAL.

CASUAL KNEELING

LEVEL:
★★★☆☆

THIS FEMININE SEATED POSE CAN BE USED TO SHOW THE BODY'S FLEXIBILITY.

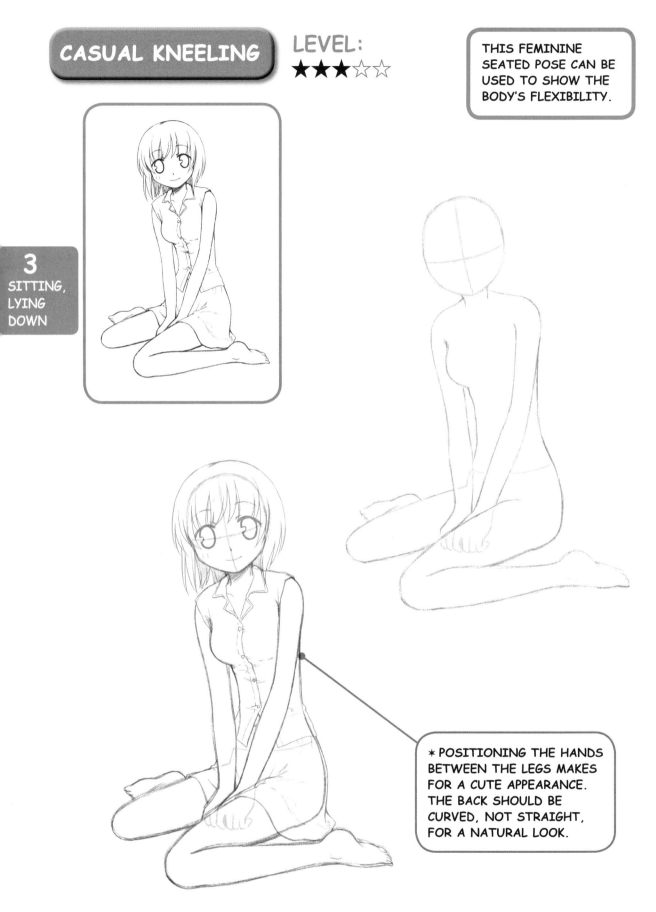

* POSITIONING THE HANDS BETWEEN THE LEGS MAKES FOR A CUTE APPEARANCE. THE BACK SHOULD BE CURVED, NOT STRAIGHT, FOR A NATURAL LOOK.

SLUMPED ON A DESK

LEVEL:
★★★★★

USE THIS POSE TO SHOW THE CHARACTER DOZING, FEELING TROUBLED, CRYING AND SO ON.

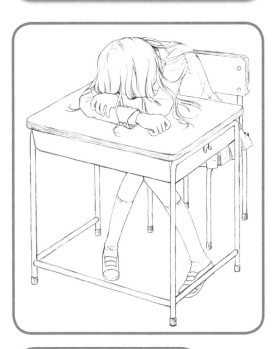

* THE HAIR FOLLOWS THE FORM OF THE ARMS AND THE DESK, FLOWING IN VARIOUS DIRECTIONS. IF YOU ARE DRAWING YOUR OWN BLOCKED-IN FIGURE, MAKE SURE TO DRAW IN THE WAIST SECTION THAT IS CONCEALED BY THE DESK.

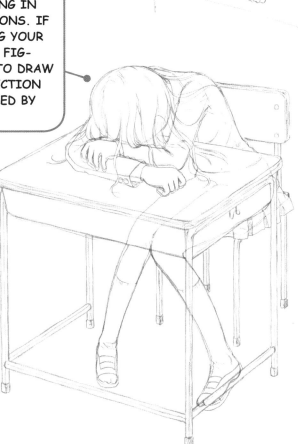

LEVEL: ★★★☆☆

USE THIS POSE FOR SCENES WHEN THE CHARACTER IS RELAXING ON THE FLOOR, ON A BED, ETC.

3
SITTING, LYING DOWN

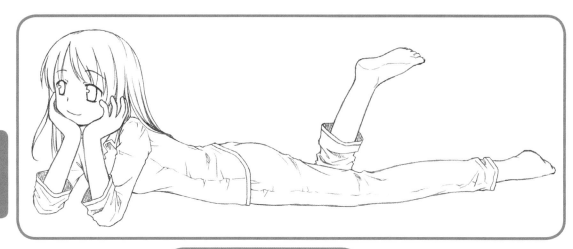

* MAKE SURE THE HANDS AND THE CHIN LINE UP PROPERLY. WHEN DRAWING YOUR OWN BLOCKED-IN FIGURE, REMEMBER TO DRAW THE CONCEALED BODY PARTS.

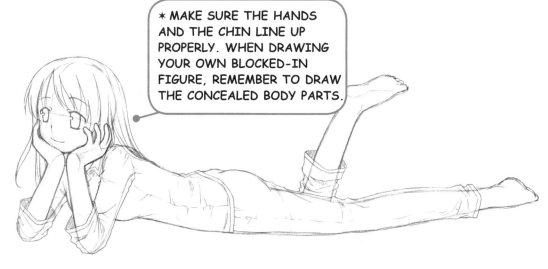

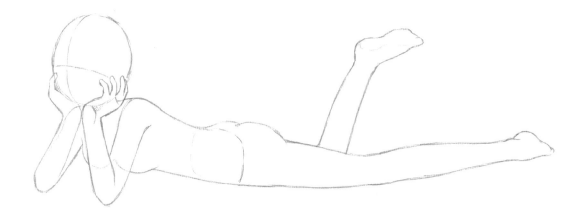

LYING ON THE SIDE

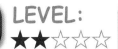

LEVEL:
★★☆☆☆

THIS POSE WORKS FOR A SLIGHTLY SLEEPY CHARACTER. COVER THE CHARACTER WITH A BLANKET FOR A SCENE IN WHICH THEY ARE FAST ASLEEP.

*EVEN THOUGH THE FACE IS ON ITS SIDE, THE HAIR HANGS STRAIGHT DOWN.

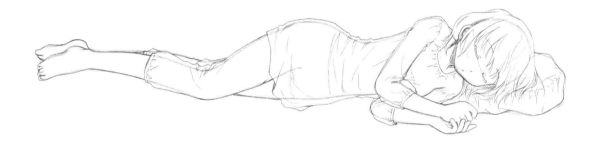

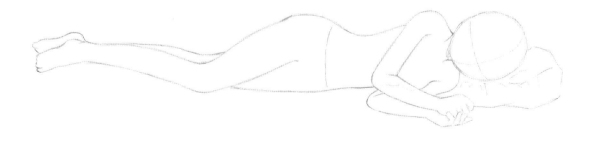

LYING WITH ONE ELBOW PROPPING UP THE HEAD

LEVEL: ★★★☆☆

THIS IS A RELAXED POSE OFTEN USED BY BOYS, DADS AND SO ON.

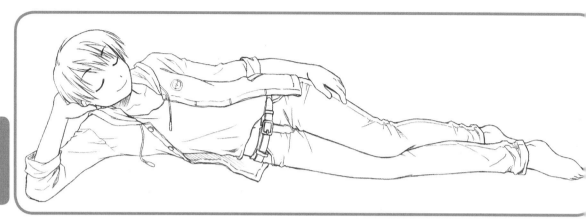

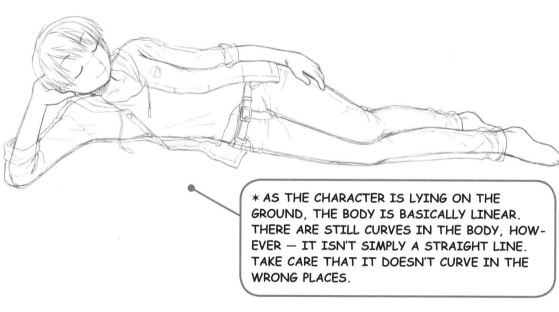

* AS THE CHARACTER IS LYING ON THE GROUND, THE BODY IS BASICALLY LINEAR. THERE ARE STILL CURVES IN THE BODY, HOW-EVER — IT ISN'T SIMPLY A STRAIGHT LINE. TAKE CARE THAT IT DOESN'T CURVE IN THE WRONG PLACES.

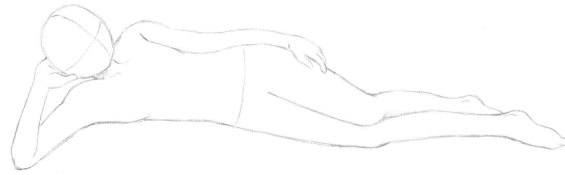

LYING ON THE BACK

LEVEL:
★★☆☆☆

WHEN FALLING ASLEEP AT NIGHT OR THINKING ABOUT THINGS, CHARACTERS OFTEN LIE ON THEIR BACKS.

* WHEN DRAWING THE TOES, FIRST DRAW THE SHAPE OF THE FEET, THEN DRAW THE FIVE TOES TO FIT WITHIN THE SHAPE.

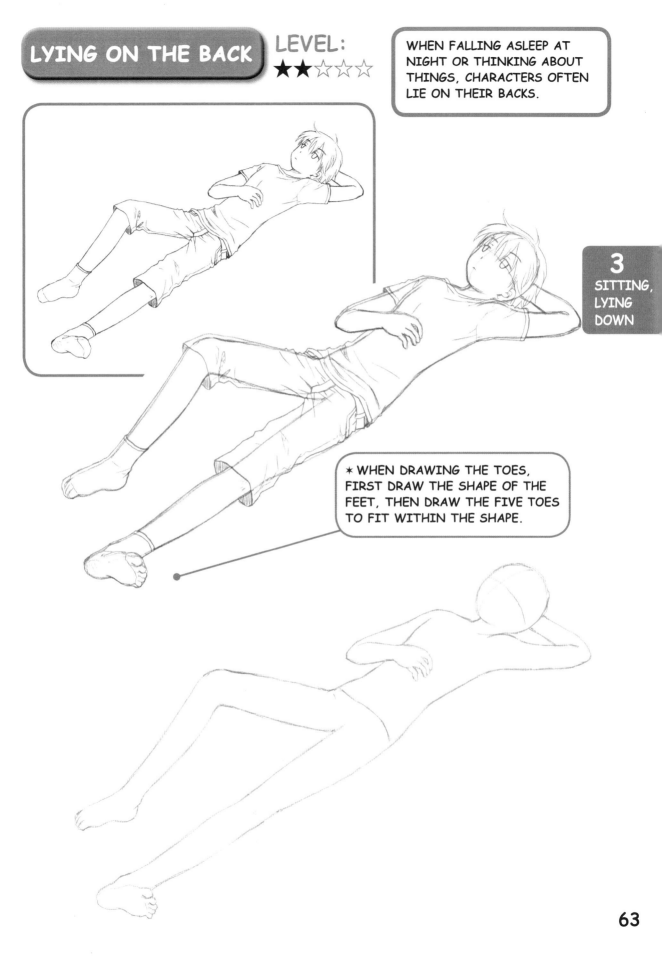

★ To get clothes to look right, pay attention to the creases, to the fabric, and to the spaces between the body and the clothing.

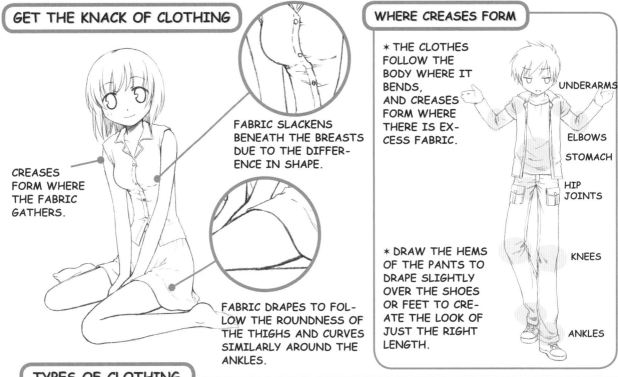

GET THE KNACK OF CLOTHING

CREASES FORM WHERE THE FABRIC GATHERS.

FABRIC SLACKENS BENEATH THE BREASTS DUE TO THE DIFFERENCE IN SHAPE.

FABRIC DRAPES TO FOLLOW THE ROUNDNESS OF THE THIGHS AND CURVES SIMILARLY AROUND THE ANKLES.

WHERE CREASES FORM

* THE CLOTHES FOLLOW THE BODY WHERE IT BENDS, AND CREASES FORM WHERE THERE IS EXCESS FABRIC.

* DRAW THE HEMS OF THE PANTS TO DRAPE SLIGHTLY OVER THE SHOES OR FEET TO CREATE THE LOOK OF JUST THE RIGHT LENGTH.

UNDERARMS

ELBOWS

STOMACH

HIP JOINTS

KNEES

ANKLES

TYPES OF CLOTHING

LIGHT AND FLOWING
DRAW THE CLOTHES TO SIT AWAY FROM THE LINE OF THE BODY. THESE CLOTHES FALL INTO LOTS OF FOLDS.

FORMFITTING
DRAW THE CLOTHING TO SIT OVER THE LINE OF THE BODY WITH MINIMAL CREASING.

LIGHT FABRICS
SHOWING THE OUTLINE OF THE LEGS CAN ILLUSTRATE THE LIGHTNESS OF THE FABRIC.

HEAVY FABRICS
DRAW THE LINE OF THE CLOTHING SLIGHTLY OUTSIDE THE BODYLINE. CREASES DO NOT FORM EASILY.

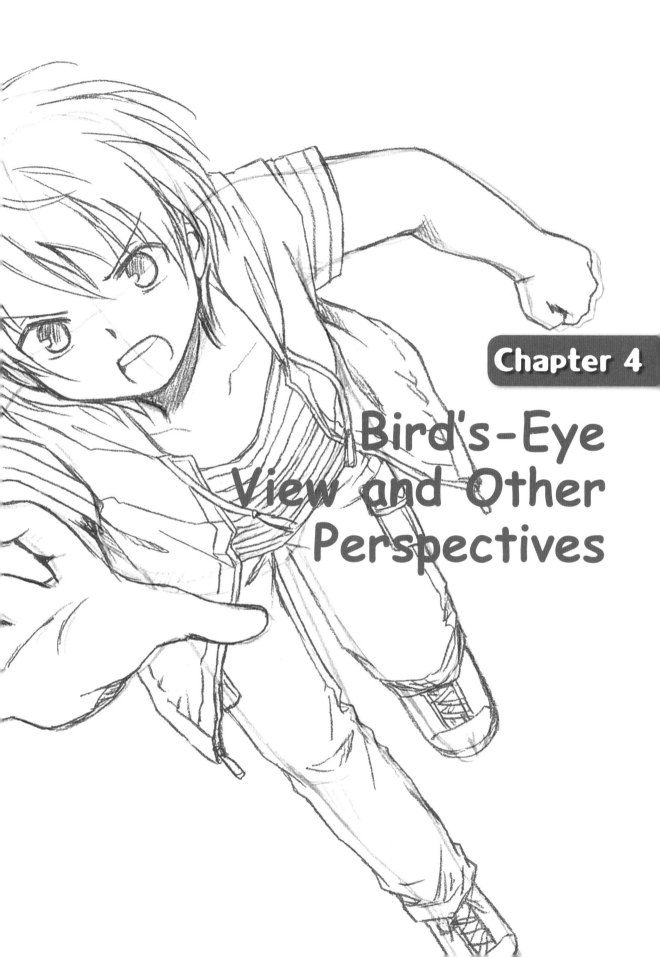

Chapter 4

Bird's-Eye
View and Other
Perspectives

STANDING (BIRD'S-EYE VIEW)

LEVEL: ★★★★☆

A BIRD'S-EYE VIEW SHOWS THE OBJECT FROM AN OVERHEAD PERSPECTIVE. IT'S USED TO SHOW CROWDS, ROOM INTERIORS, AND OTHER SITUATIONS WHERE THE SURROUNDINGS NEED TO BE MADE CLEAR, OFTEN FROM A SLIGHT DISTANCE.

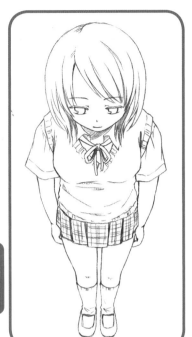

4
BIRD'S-EYE VIEW

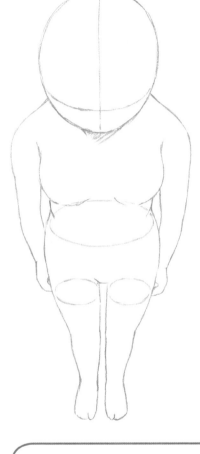

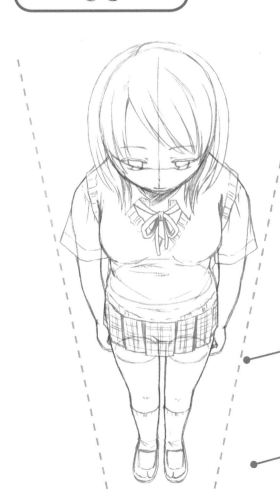

* REFER TO THE EXPLANATION ABOUT TRIANGLES ON PAGE 76 AND MAKE SURE THE BODY TAPERS THE CLOSER IT GETS TO THE GROUND.

* DRAWING THE FEET TO LOOK TINY ADDS TO THE EFFECT OF AN OVERHEAD PERSPECTIVE.

STANDING (VIEWED FROM BELOW)

LEVEL:
★★★★☆

TILTING THE PERSPECTIVE TO SHOW THE SUBJECT OF THE DRAWING FROM BELOW CAN BE USED NOT ONLY FOR PEOPLE, BUT ALSO FOR MODERN BUILDINGS, SCHOOLS, AND OTHER STRUCTURES WITH HEIGHT.

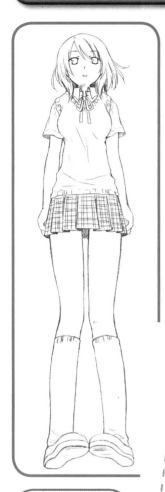

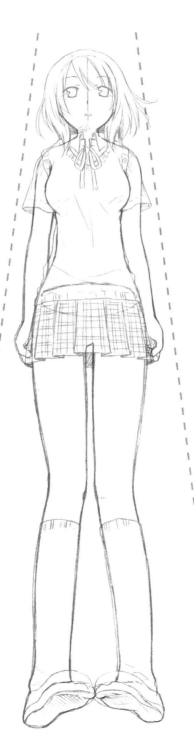

✳ THE LINE OF THE CHIN, SLEEVES OF THE SHIRT, HEM OF THE SKIRT AND SO ON ALL TEND TO TAKE ON A CURVE THAT PEAKS IN THE CENTER.

4
BIRD'S-EYE VIEW

STANDING (ANGLED BIRD'S-EYE VIEW)

LEVEL: ★★★☆☆

DEPICTING THE CHARACTER FROM OVERHEAD WITH HIS BODY AT AN ANGLE ADDS A DRAMATIC AIR.

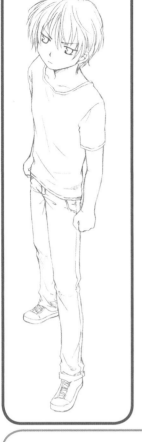

* BEFORE TRACING, DRAW THE INVERSE TRIANGLE OUTLINED ON PAGE 76 TO PREVENT THE LEGS BECOMING TOO LONG.

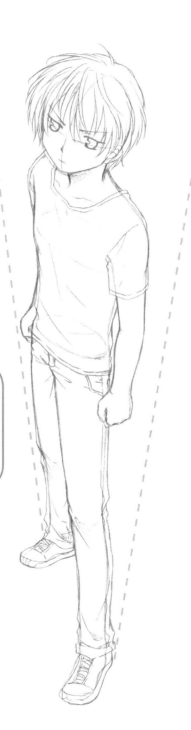

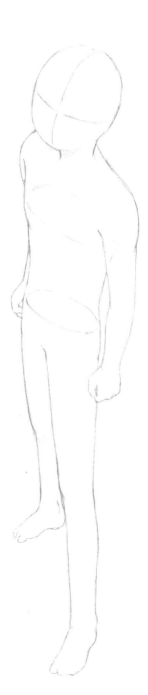

STANDING (VIEWED AT AN ANGLE FROM BELOW)

LEVEL:
★★☆☆☆

SETTING THE BODY AT AN ANGLE WHEN DRAWING IT FROM BELOW ADDS IMPACT. IT SUITS A SCENE WITH TENSION AND DRAMA, SUCH AS THE LEAD-IN TO A CONFRONTATION.

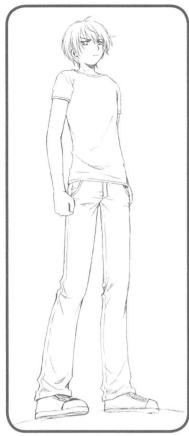

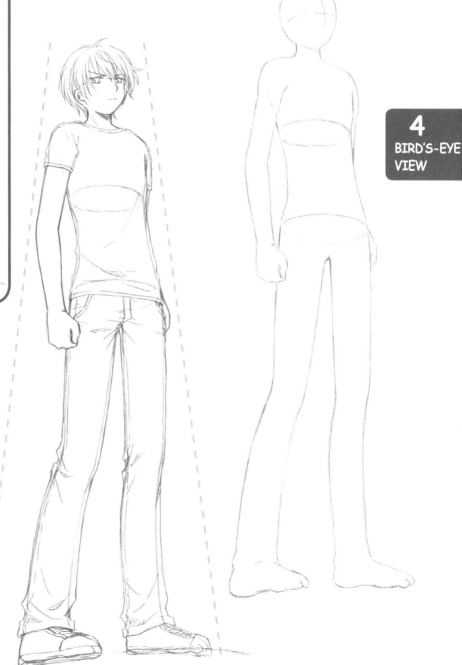

4
BIRD'S-EYE VIEW

∗ KEEPING IN MIND THE ELLIPTICAL SHAPE WITHIN THE STOMACH THAT IS OUTLINED ON PAGE 76, TRY TRACING THE FIGURE.

HANDS ON HIPS (BIRD'S-EYE VIEW)

LEVEL: ★★★☆☆

EVEN THOUGH THIS POSE IS NEARLY THE SAME AS THE ONE ON PAGE 34, SIMPLY USING A BIRD'S-EYE PERSPECTIVE CREATES THE IMPRESSION THAT THE CHARACTER IS TALKING TO SOMEONE.

4
BIRD'S-EYE VIEW

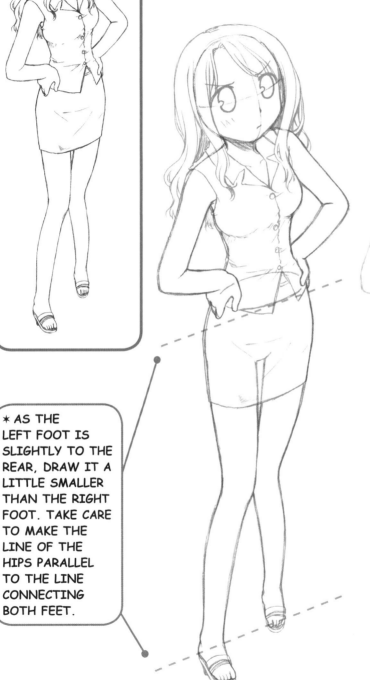

* AS THE LEFT FOOT IS SLIGHTLY TO THE REAR, DRAW IT A LITTLE SMALLER THAN THE RIGHT FOOT. TAKE CARE TO MAKE THE LINE OF THE HIPS PARALLEL TO THE LINE CONNECTING BOTH FEET.

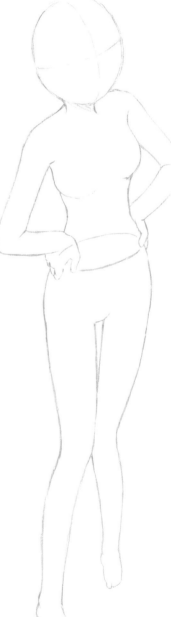

HANDS ON HIPS (VIEWED AT AN ANGLE FROM BELOW)

USE THIS POSE TO SHOW THE CHARACTER BECOMING ANGRY AT SOMEONE OR IN A TEACHING SCENE. THE SAME POSE LOOKS QUITE DIFFERENT WHEN SHOWN FROM DIFFERENT ANGLES.

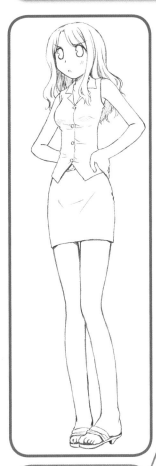

LEVEL:
★★★☆☆

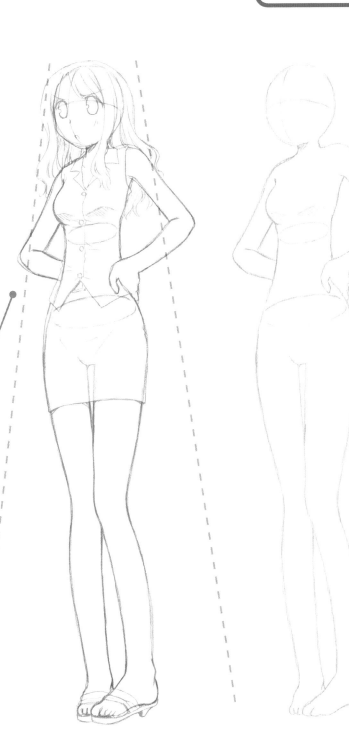

4
BIRD'S-EYE VIEW

* IF YOU ARE DOING THE BLOCKING-IN YOURSELF, MAKE SURE TO DRAW THE HAND TO THE REAR RESTING FIRMLY ON THE HIP.

JUMPING (BIRD'S-EYE VIEW)

LEVEL: ★★☆☆☆

USE THIS POSE TO SHOW HAPPINESS OR A CHARACTER FULL OF ENERGY. USING A BIRD'S-EYE PERSPECTIVE HERE REALLY MAKES THE CHARACTER SEEM TO JUMP OFF THE PAGE!

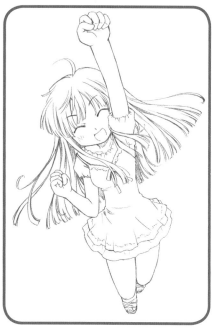

4
BIRD'S-EYE VIEW

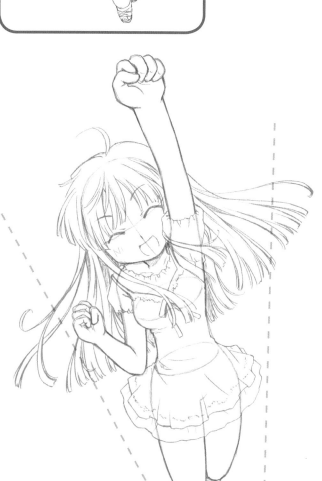

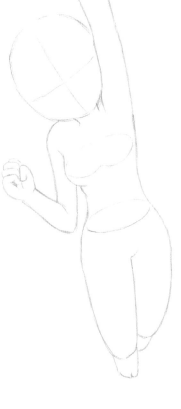

* MAKING THE RAISED HAND LARGE CREATES DEPTH AND INCREASES IMPACT.

SNAPPILY POINTING A FINGER
(VIEWED FROM BELOW)

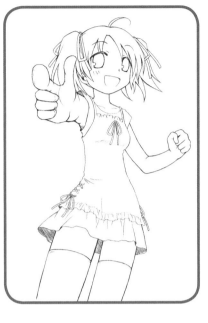

LEVEL:
★★★★★

4
BIRD'S-EYE
VIEW

THIS BOLD POSE MAKES USE OF DISTORTION (DELIBERATELY DEPICTING A PARTICULAR BODY PART AS LARGER OR LESS OBVIOUS FOR THE PURPOSE OF CREATING A COOL LOOK).

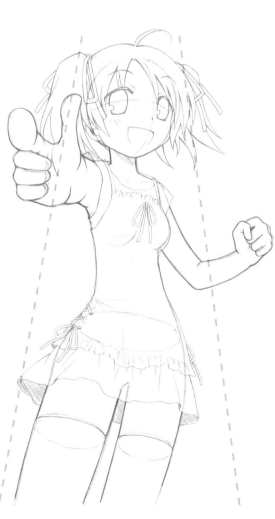

∗ THIS POSE GOES BEST WITH A BRILLIANT SMILE OR CLEAR-CUT FACIAL EXPRESSION. IF THE FACIAL FEATURES ARE VAGUE, IT CAN LOOK UNNATURAL. YOU MIGHT FIND IT DIFFICULT AT FIRST TO DRAW THE EXTENDED FINGER FRONT-ON, BUT CHALLENGE YOURSELF TO TRY THIS DISTORTION TECHNIQUE.

SUDDENLY ARRIVING (VIEWED FROM BELOW)

LEVEL: ★★★★☆

THIS CAN BE USED WHEN LANDING FROM A JUMP, AFTER SPRINTING AND OTHER TIMES WHEN A CHARACTER COMES TO A SUDDEN STOP.

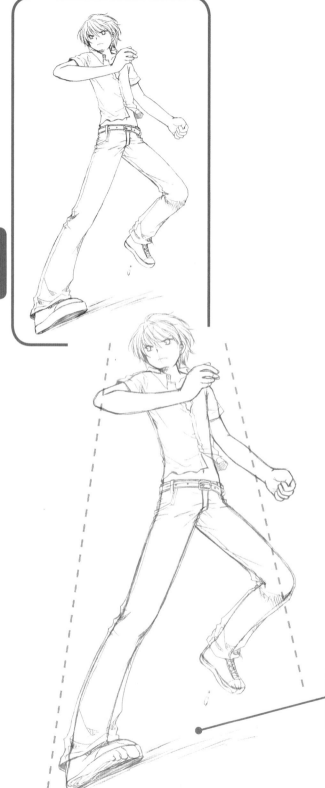

4
BIRD'S-EYE VIEW

* MAKE THE FOOT IN THE FOREGROUND HUGE AND POWERFUL. THE HAIR FLUTTERS IN THE WIND.

A RUNNING APPROACH (BIRD'S-EYE VIEW)

LEVEL: ★★★★☆

COMBINED WITH A SERIOUS EXPRESSION, THIS POSE WORKS FOR A SPRINTING CHARACTER. IT CAN ALSO BE USED WITH A COMICAL TOUCH TO SHOW A CHARACTER STUMBLING OR TRIPPING.

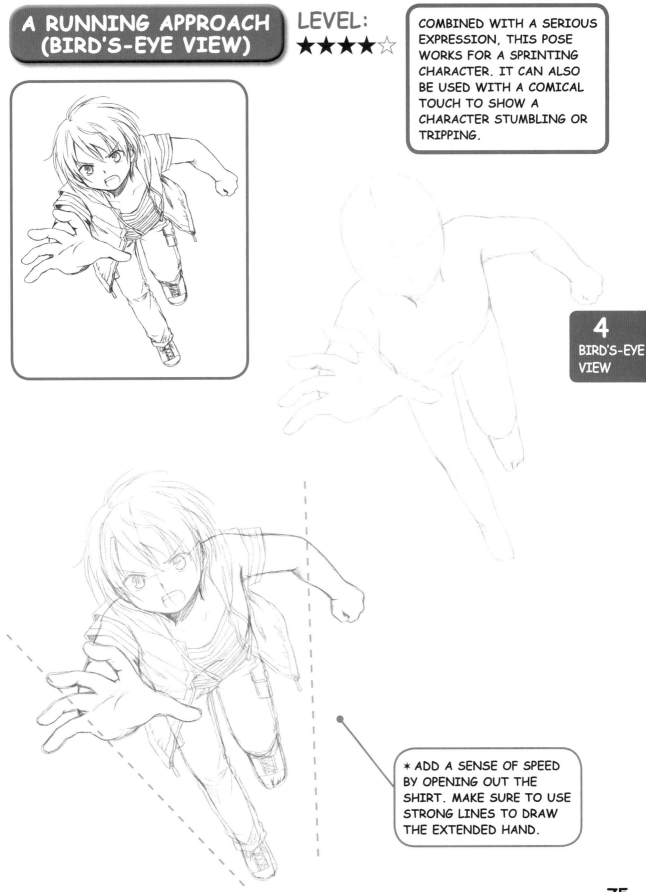

4
BIRD'S-EYE VIEW

* ADD A SENSE OF SPEED BY OPENING OUT THE SHIRT. MAKE SURE TO USE STRONG LINES TO DRAW THE EXTENDED HAND.

DRAW INSIDE A TRIANGLE

★ When using distortion, drawing the character as if they are inside a triangle instantly creates good composition. In basic terms, bird's-eye view uses a triangle, while an inverse triangle is used to show a character from below.

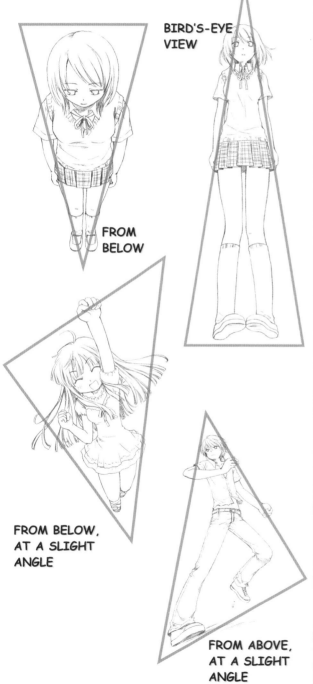

BIRD'S-EYE VIEW

FROM BELOW

FROM BELOW, AT A SLIGHT ANGLE

FROM ABOVE, AT A SLIGHT ANGLE

MAKE USE OF OVALS

★ When viewing people's bodies from above or below, the thickness of the chest and stomach area appears oval in shape. Keep the oval shape in mind as you draw to prevent bodies looking too thin or flat.

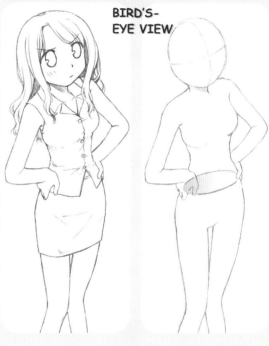

BIRD'S-EYE VIEW

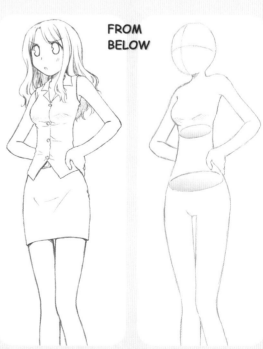

FROM BELOW

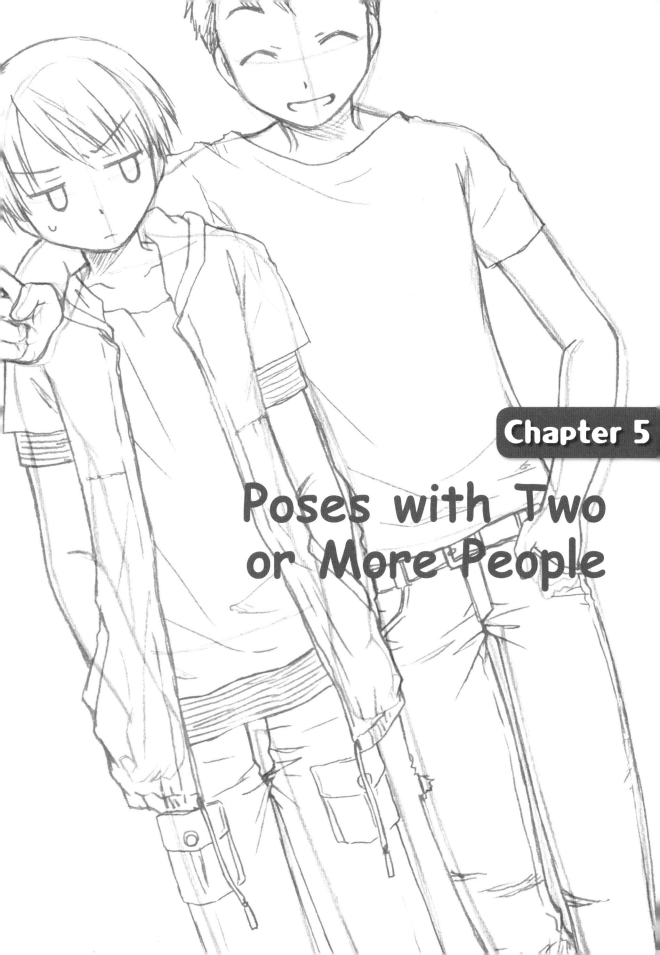

Chapter 5

Poses with Two or More People

WALKING WITH ARMS LINKED

LEVEL: ★★★☆☆

DEPENDING ON THEIR FACES, THIS POSE COULD BE FOR A LOVED-UP COUPLE OR FOR TWO PEOPLE GRABBING EACH OTHER'S ARMS IN FEAR.

5
TWO OR MORE PEOPLE

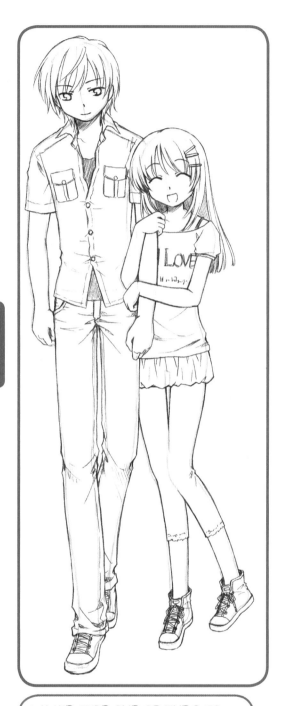

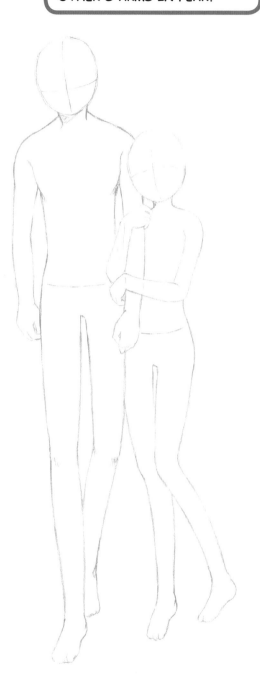

✻ MAKE SURE ONE OF THE PAIR ISN'T FLOATING OFF THE GROUND. WHEN DRAWING FROM THE BLOCKING-IN STAGE, ADJUST AS YOU GO TO MAKE SURE THE HEADS ARE AROUND THE SAME SIZE.

AN ARM AROUND THE SHOULDERS

LEVEL: ★★★☆☆

THIS SHOWS THAT TWO PEOPLE GET ALONG WELL, ALTHOUGH IF ONE IS LOOKING ANNOYED, IT CAN CHANGE THE VIBE!

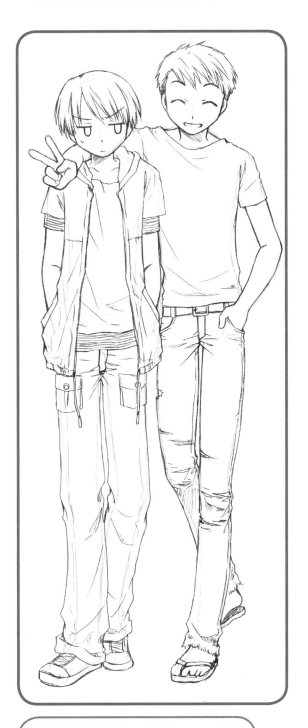

* DRAW IN THE ARM BEHIND THE SHOULDER AT THE BLOCKING-IN STAGE TO GET THE HAND POSITION CORRECT. DO THE SAME FOR THE HAND IN THE POCKET.

CARRYING A GIRL

LEVEL: ★★★★☆

IF THE TWO CHARACTERS ARE SMILING THIS CAN BE USED FOR A ROMANTIC SITUATION, WHILE SERIOUS FACIAL EXPRESSIONS WORK IF THEY ARE DESPERATELY TRYING TO ESCAPE.

★ IT'S EASY TO GET THE LENGTH OF THE FEMALE CHARACTER'S LEGS WRONG, SO WHEN DRAWING THE BLOCKED-IN FIGURES, FILL IN THE CONCEALED AREAS TOO.

5
TWO OR MORE PEOPLE

SWINGING A CHILD IN THE AIR

LEVEL: ★★★☆☆

THIS POSE SUITS A SCENE SHOWING THE LOVE BETWEEN A PARENT AND CHILD. DRAW THE CHARACTERS TO LOOK HAPPY.

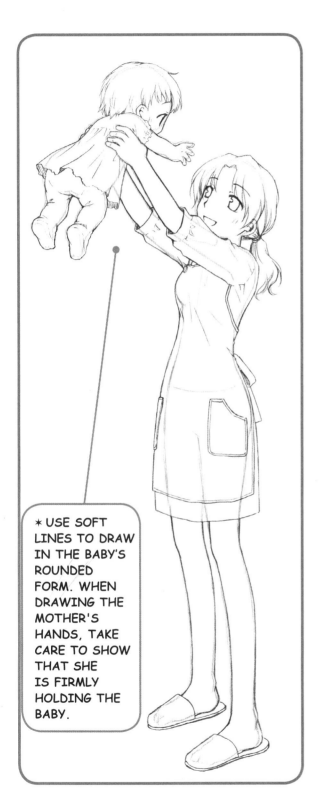

* USE SOFT LINES TO DRAW IN THE BABY'S ROUNDED FORM. WHEN DRAWING THE MOTHER'S HANDS, TAKE CARE TO SHOW THAT SHE IS FIRMLY HOLDING THE BABY.

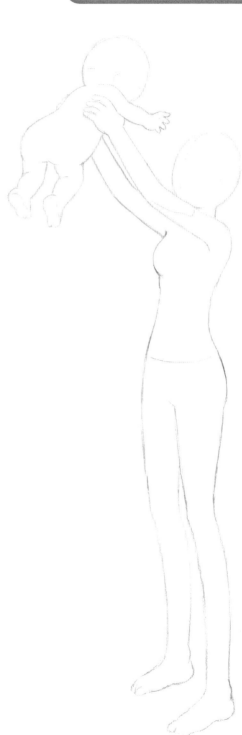

5
TWO OR MORE PEOPLE

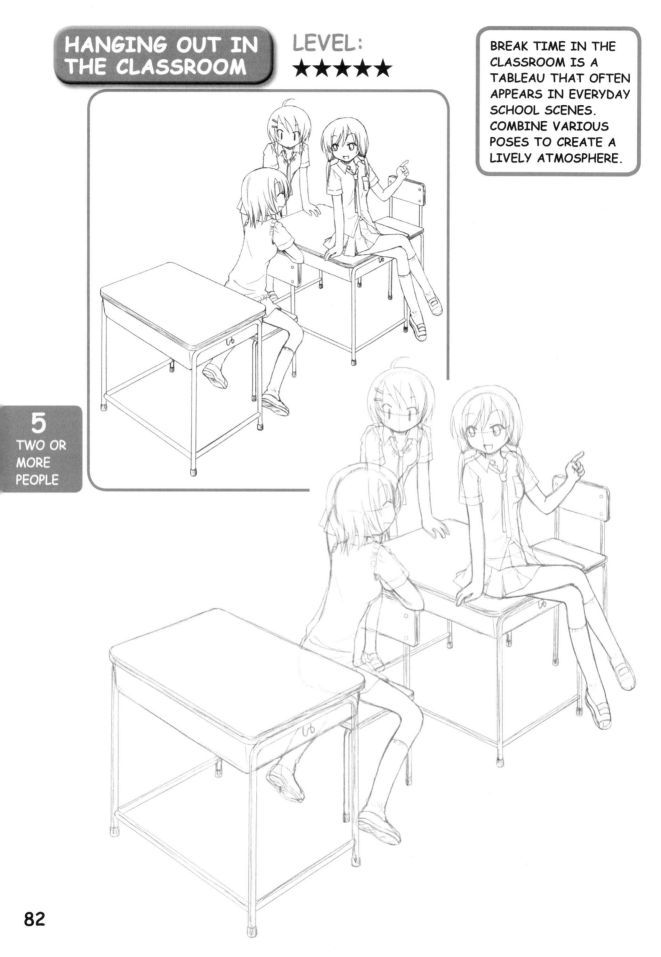

HANGING OUT IN THE CLASSROOM

LEVEL: ★★★★★

BREAK TIME IN THE CLASSROOM IS A TABLEAU THAT OFTEN APPEARS IN EVERYDAY SCHOOL SCENES. COMBINE VARIOUS POSES TO CREATE A LIVELY ATMOSPHERE.

5
TWO OR MORE PEOPLE

* IF THE CHARACTERS ARE TALKING, MAKE SURE THAT THEIR EYES MEET. WHEN DRAWING ITEMS OF FURNITURE SUCH AS DESKS, PAY ATTENTION TO SIZE, MAKING SURE THAT THEY ARE NEITHER TOO LARGE OR TOO SMALL IN RELATION TO THE FIGURES.

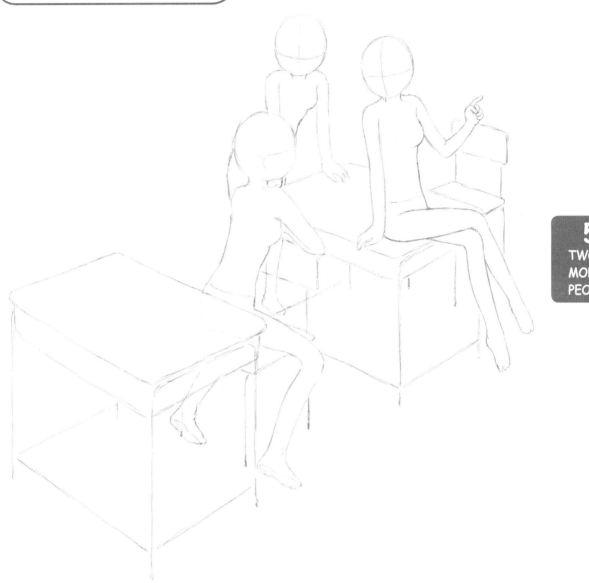

5
TWO OR MORE PEOPLE

★ When drawing a pose where the characters are touching, don't forget to think about the parts of the body that are concealed.

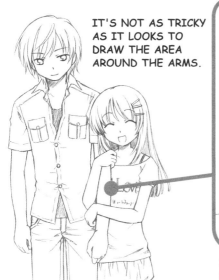

IT'S NOT AS TRICKY AS IT LOOKS TO DRAW THE AREA AROUND THE ARMS.

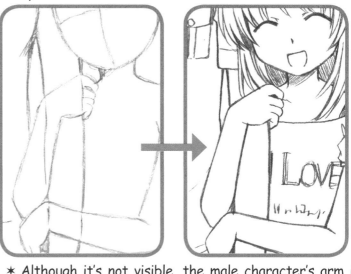

★ Although it's not visible, the male character's arm is beneath the female's. Keep this in mind as you draw to achieve a well-formed arm and natural-looking embrace.

BEHIND OBJECTS

DRAW IN LEGS, BUTTOCKS AND OTHER BODY PARTS CLEARLY AT THE BLOCKING-IN STAGE EVEN IF THEY ARE CONCEALED BEHIND A DESK. THIS WILL PREVENT BODY PARTS FROM STICKING OUT IN STRANGE POSITIONS.

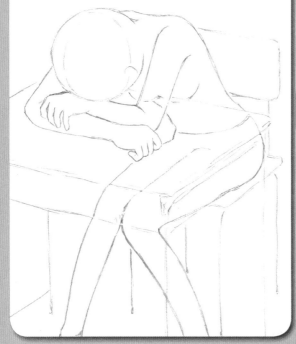

HIDDEN PARTS OF THE BODY

KEEP IN MIND THE BLOCKING-IN LINES FOR PARTS OF THE BODY HIDDEN BY THE ARMS OR HANDS. THIS WILL PREVENT THE NECK, HEAD, ETC FROM BEING IN THE WRONG POSITION.

WHEN SEATED WITH KNEES DRAWN UP, THE ARMS REST ON THE KNEES. IF YOU BLOCK IN THE KNEES, YOU WON'T HAVE TO WORRY ABOUT THE ARMS HANGING STRANGELY IN THE WRONG SPOT.

Chapter 6

Setting
the Scene

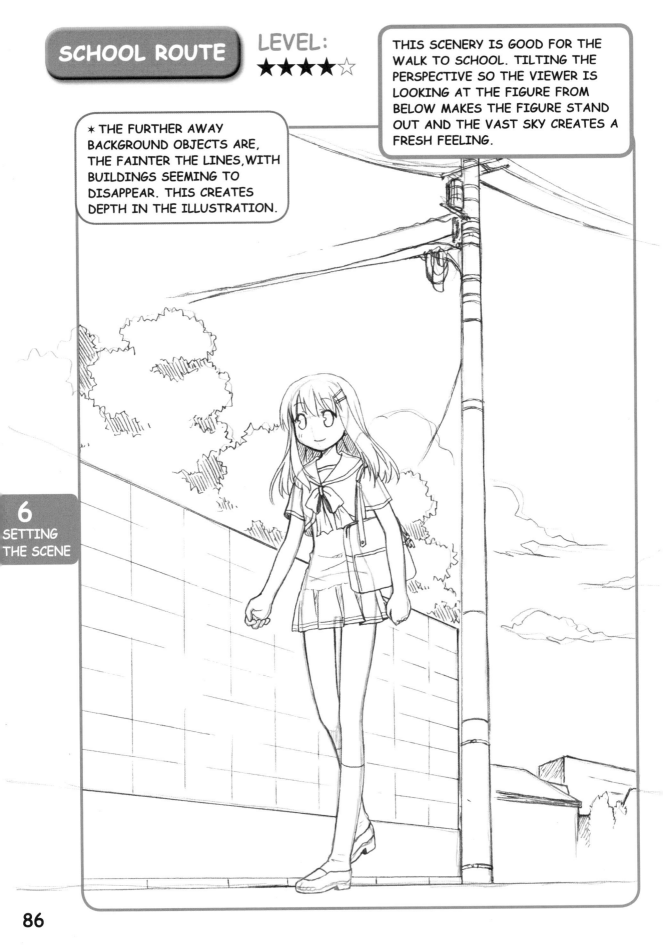

SCHOOL ROUTE

LEVEL: ★★★★☆

THIS SCENERY IS GOOD FOR THE WALK TO SCHOOL. TILTING THE PERSPECTIVE SO THE VIEWER IS LOOKING AT THE FIGURE FROM BELOW MAKES THE FIGURE STAND OUT AND THE VAST SKY CREATES A FRESH FEELING.

✱ THE FURTHER AWAY BACKGROUND OBJECTS ARE, THE FAINTER THE LINES, WITH BUILDINGS SEEMING TO DISAPPEAR. THIS CREATES DEPTH IN THE ILLUSTRATION.

6
SETTING
THE SCENE

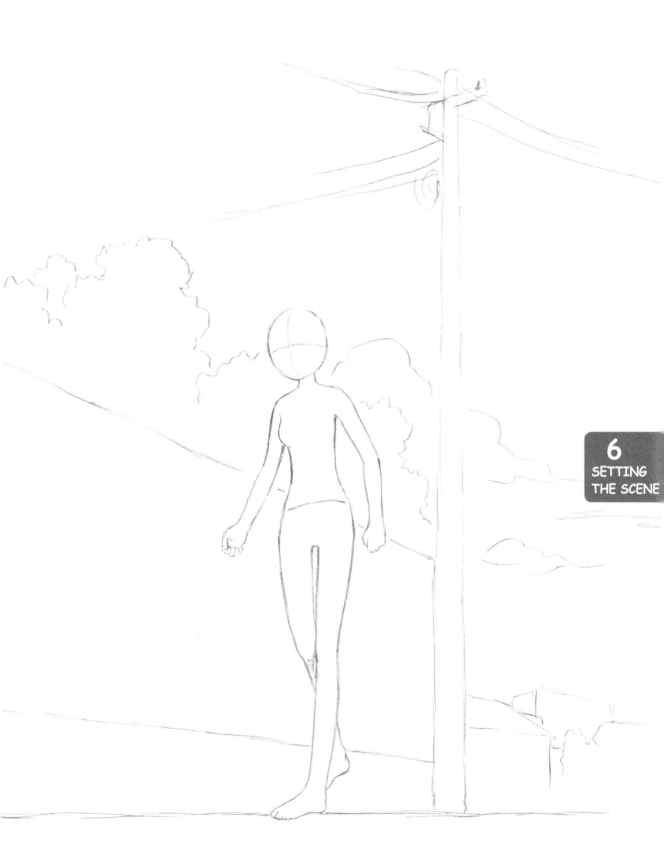

6
SETTING
THE SCENE

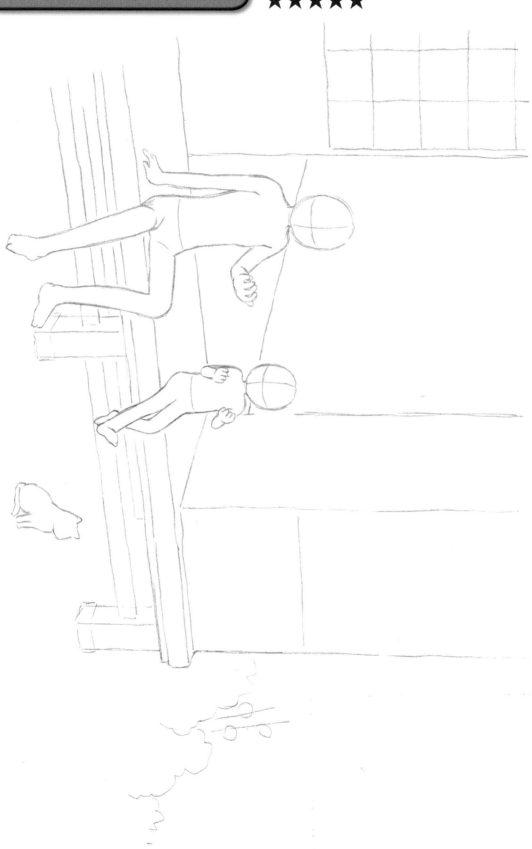

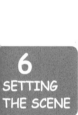

6
SETTING
THE SCENE

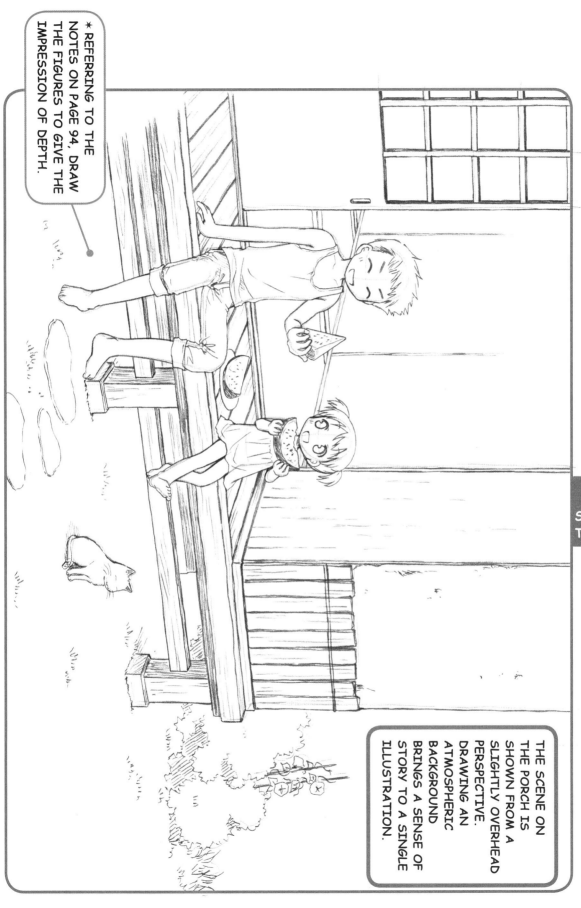

★ REFERRING TO THE NOTES ON PAGE 94, DRAW THE FIGURES TO GIVE THE IMPRESSION OF DEPTH.

THE SCENE ON THE PORCH IS SHOWN FROM A SLIGHTLY OVERHEAD PERSPECTIVE. DRAWING AN ATMOSPHERIC BACKGROUND BRINGS A SENSE OF STORY TO A SINGLE ILLUSTRATION.

6
SETTING THE SCENE

MANGA 1: SHOJO MANGA STYLE

 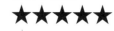

USING THE BLOCKING-IN OF A PROFESSIONAL MANGA ARTIST, HAVE A GO AT CREATING YOUR OWN DRAWING. EVEN IF YOU'RE NOT GOOD AT PANEL LAYOUTS, USE THIS BLOCKING-IN AS A BASE FOR CREATING AN ORIGINAL SCENE.

MANGA: JUNKA MOROZUMI

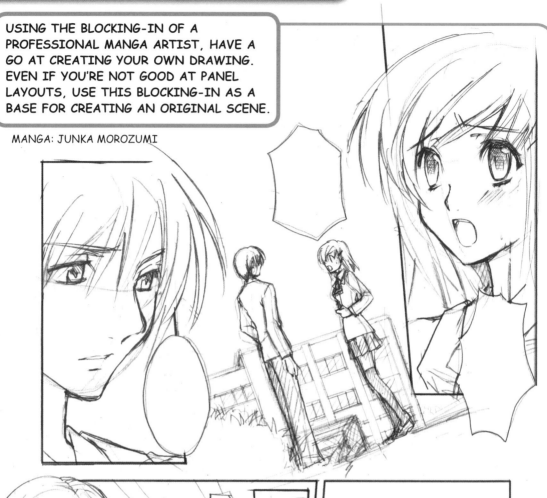

6
SETTING THE SCENE

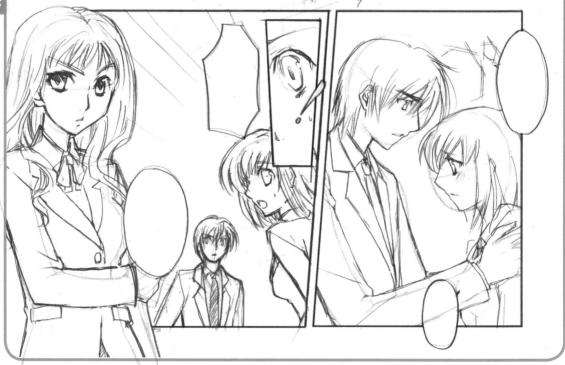

90

* "SHOJO MANGA" MEANS GIRLS' COMICS. THE MAIN FEMALE CHARACTER IS ALWAYS CUTE AND THE MAIN MALE CHARACTER COOL! MAKE SURE YOU SHOW THEIR MUTUAL ADORATION. DRAW NEATLY NOT JUST FOR CLOSEUPS OF FACES BUT FOR FULL-LENGTH PICTURES TOO.

6
SETTING
THE SCENE

LEVEL:
★★★★★

"SHONEN MANGA" MEANS BOYS' COMICS. ARE YOU BETTER AT SHONEN OR SHOJO?

6
SETTING THE SCENE

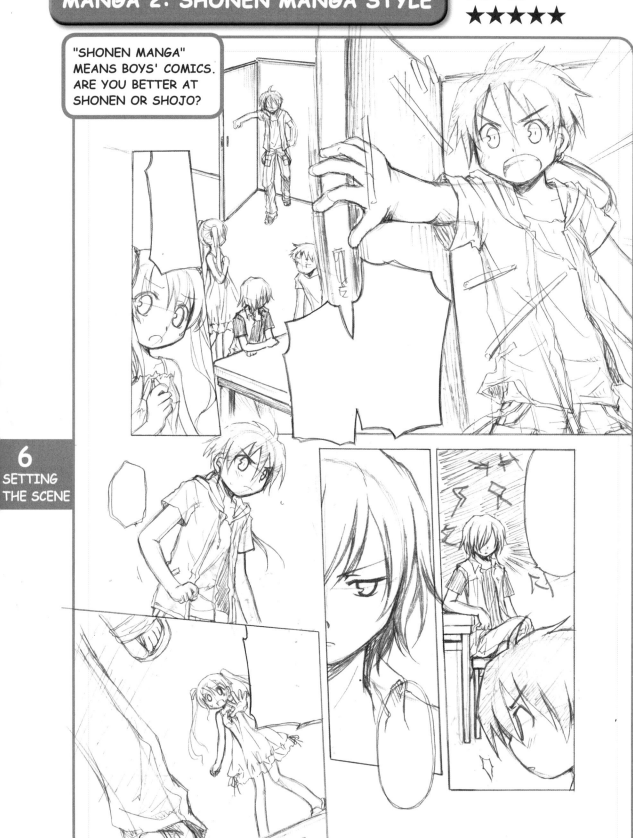

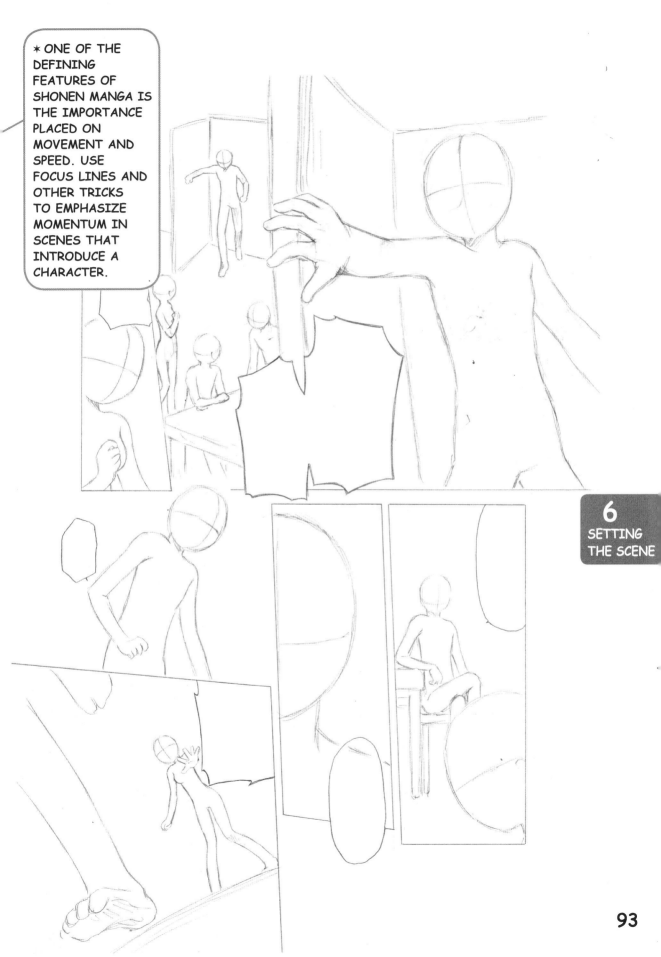

* ONE OF THE DEFINING FEATURES OF SHONEN MANGA IS THE IMPORTANCE PLACED ON MOVEMENT AND SPEED. USE FOCUS LINES AND OTHER TRICKS TO EMPHASIZE MOMENTUM IN SCENES THAT INTRODUCE A CHARACTER.

6
SETTING
THE SCENE

★ Knowing how to make arms and legs shorter is helpful for bringing out depth in a picture. As shown below, when depicting a person bending their arm from front on, the forearm gets gradually shorter until it cannot be seen at all. Mastering this trick will greatly increase the range of poses you can draw.

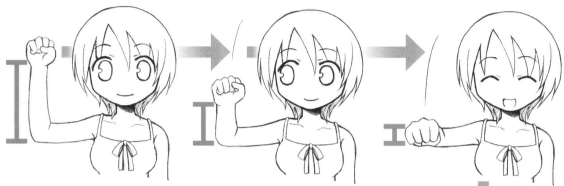

THE FURTHER DOWN THE FOREARM GOES, THE SHORTER IT GETS (OR APPEARS TO GET)

WHEN THE ARM EXTENDS FORWARD, THE UPPER ARM IS ALSO SHORTENED. DRAW THE HAND IN FRONT TO LOOK HUGE!

PUNCH

SHORT LIMBS ADD DEPTH

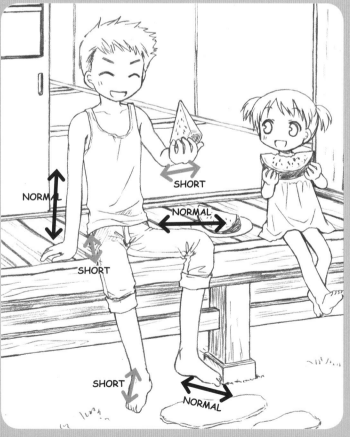

NORMAL

SHORT

NORMAL

SHORT

SHORT

NORMAL

★ In the picture to the left, the boy's body is given dimension by making the right thigh and right foot slightly shorter than normal length. Strangely, even exaggerated shortening (to the point that you can't believe it's OK) turns out fine! The more you draw, the more you will find your own sense of balance, so give it a go!

IT'S A BIT TRICKY, BUT ONCE YOU GET THE HANG OF IT, IT'S SUCH A HANDY TECHNIQUE!

94

AFTERWORD

The idea for this book came about all of a sudden when we were exchanging advice about drawing. We were both on our home phones, but although we were apart, we were using a paint-and-chat platform on the Internet to explain tricky-to-draw poses to each other.

"I'm doing the blocking-in, but I still can't get the drawing right!"

"Maybe it's the blocking-in that's the problem?"

One of us started using a faint color to block in a figure, while the other one had a go at drawing her own illustration over the top... that was the "aha moment" for us and the start of our "blocking-in revolution." We felt exactly like two characters on the opening pages of a manga!

In our long years as manga illustrators, we know firsthand that even if you practice drawing a lot, it's still easy to make mistakes related to balance and proportion, which you might not even notice yourself.

As you've been tracing over the pictures in this book, and studying the key-point guidance notes, you've probably ended up with some great looking illustrations as a result.

We sincerely hope that this book has helped you to enjoy drawing even more than you did before!

About Tuttle
"Books to Span the East and West"

Our core mission at Tuttle Publishing is to create books which bring people together one page at a time. Tuttle was founded in 1832 in the small New England town of Rutland, Vermont (USA). Our fundamental values remain as strong today as they were then—to publish best-in-class books informing the English-speaking world about the countries and peoples of Asia. The world has become a smaller place today and Asia's economic, cultural and political influence has expanded, yet the need for meaningful dialogue and information about this diverse region has never been greater. Since 1948, Tuttle has been a leader in publishing books on the cultures, arts, cuisines, languages and literatures of Asia. Our authors and photographers have won numerous awards and Tuttle has published thousands of books on subjects ranging from martial arts to paper crafts. We welcome you to explore the wealth of information available on Asia at www.tuttlepublishing.com.

www.tuttlepublishing.com

ATARI KAKUMEI
Copyright © Junka Morozumi, Tomomi Mizuna 2009
English translation rights arranged with MAAR-sha Publishing Co., Ltd., through Japan UNI Agency, Inc., Tokyo.

English translation ©2019 Periplus Editions (HK) Ltd.

ISBN 978-4-8053-1510-1

Distributed by:

North America, Latin America & Europe
Tuttle Publishing
364 Innovation Drive, North Clarendon
VT 05759-9436 U.S.A.
Tel: 1 (802) 773-8930; Fax: 1 (802) 773-6993
info@tuttlepublishing.com;
www.tuttlepublishing.com

Japan
Tuttle Publishing
Yaekari Building 3rd Floor
5-4-12 Osaki Shinagawa-ku, Tokyo 141 0032
Tel: (81) 3 5437-0171; Fax: (81) 3 5437-0755
sales@tuttle.co.jp; www.tuttle.co.jp

Asia Pacific
Berkeley Books Pte. Ltd.
3 Kallang Sector, #04-01/02, Singapore 349278
Tel: (65) 6741-2178; Fax: (65) 6741-2179
inquiries@periplus.com.sg; www.tuttlepublishing.com

Printed in Hong Kong 1904EP
22 21 20 19 10 9 8 7 6 5 4 3 2 1